Images of Modern America

DIVING OFF THE OREGON COAST

The Oregon Coast

An illustration of the Oregon coast is pictured here. (Courtesy of Floyd Holcom.)

FRONT COVER: Although the wolf eel (actually a bottom fish) has large, intimidating teeth and opens and closes its mouth when filtering water through the gills to breathe, which certainly looks a bit scary, it is very friendly and enjoys being lightly petted and hand-fed spiny sea urchins when a diver breaks open the shell. (Courtesy of Tom Hemphill.)

UPPER BACK COVER: A group of divers in the early 1960s gets ready for a spearfishing competition. The paddleboards, for the most part, were custom made by or for each diver. (Courtesy of Bill High.)

LOWER BACK COVER (from left to right): This photograph of the shoreline illustrates the beauty of the rugged Oregon coastline and outer rocks and reefs (Courtesy of Jim Burke); the water off the Oregon coast is often very clear, even in close where the kelp grows on the shallow reefs (Courtesy of Jim Burke); a very large Sunburst sea star (starfish) (Courtesy of Tom Hemphill)

Nice to meet you Zan

Tam

Images of Modern America

DIVING OFF THE OREGON COAST

Thank you
Happy Diving
Tam Hemphill

TOM HEMPHILL AND FLOYD HOLCOM

ARCADIA
PUBLISHING

Published by Arcadia Publishing
Charleston, South Carolina

Printed in the United States of America

Library of Congress Control Number: 2016937117

For all general information, please contact Arcadia Publishing:
Telephone 843-853-2070
Fax 843-853-0044
E-mail sales@arcadiapublishing.com
For customer service and orders:
Toll-Free 1-888-313-2665

Visit us on the Internet at www.arcadiapublishing.com

*We dedicate this book to the many diving pioneers who first
accepted the challenges of diving the Oregon coast.*

CONTENTS

ACKNOWLEDGMENTS

This has been a challenging and extremely rewarding experience for us both, as we made contact with many divers, some old friends, and some new friends as well. We sincerely thank our friends and associates for their contributions to support this book. We needed about 160 photographs and we collected more than 500 photographs, just by asking our friends. We must also acknowledge the fact that we left out a lot of diving pioneers, some dive clubs, and a few dive stores. We can assure you it was not intentional.

We are sincerely blessed to have had the support from so many people that provided photographs, stories, secrets, and history to share with you. Thank you, Sid Macken (Salem, Oregon, diver since the 1960s, commercial diver, and underwater filmmaker), for the photographs, especially those from the 1950s and 1960s; John Ratliff (Hillsboro, Oregon, NAUI instructor since the 1960s and BC inventor), for the images of your diving youth at the Oregon coast; Laurie Hannula (owner of Pacific Watersports in Aloha, Oregon, and PADI and NAUI instructor), for the visit, photographs, and tour of your vintage dive gear collection; Paul Schorzman (NAUI, SSI, and NASDS instructor and founder of Tri-West Scuba School and the Diving Bell dive store in Portland in 1970), for all of the old photographs; Ron Tinker (owner of Adventure Sports Scuba in Wood Village), for the visit, the history lesson, and photographs; Michael and Diana Hollingshead (owners of Eugene Skin Diving Supply), for your images and assistance in getting connected with the Oregon Coast Aquarium; Jim Burke (director of animal husbandry) and Lance Beck from the Oregon Coast Aquarium, for the great photographs; Ron Brockleman (scuba instructor and Tom Hemphill's old friend), for dragging some old stories out of my memory banks; Jim Larsen (NAUI regional rep), for making connections with several people that assisted with photographs; Mark Fischer (PADI instructor and owner of Hydro Sports Dive & Travel in Salem, Oregon), for the photographs; and Rod Shroufe and Dan Semrad II (NAUI instructors and owners of Scuba Specialties NW in Oregon City), for the great images and guidelines for some of the popular dive sites.

The groups from Eugene and Newport were extremely helpful with photographs, details on specific diving locations, information on the Oregon Coast Aquarium, and memories of one of our great pioneers, Don Hollingshead.

Several dive clubs contributed photographs and information on the club history. Thank you, Don McCoy, Portland Sea Searchers; Jim Pendergrass, Eugene Dive Club; and Jeff Groth, Oregon Scuba Club.

Most of the great underwater photographs were taken by Steve Zedekar, and the photographs of spearfishing were taken by Josh Humbert. These guys are real professionals and we appreciate being able to include their photographs.

We apologize if we missed anyone; we have a lot of people to thank.

INTRODUCTION

The first chapter of this book will highlight the primary attractions for divers to the Oregon coast, including some great photographs of some marine life that one probably would not expect to see off of the Oregon coast. Readers will be amazed at the brilliant colors of some of the anemone, nudibranch, and small fish.

The Oregon coast is one of the most beautiful places on earth and a very popular, year-round tourist destination. The scenic attractions include overwhelming views of a very rugged coastline with rocky cliffs and sandy beaches. Driving along US Highway 101 from Astoria, Oregon, south to the California border is a slow, sightseeing route for more than 360 miles.

Most visitors—while looking from the shore at the rugged rocks, massive kelp forests, breakers on the beaches, waves slamming into the cliffs, and offshore rocks sticking up from the reefs— simply cannot imagine anyone actually choosing to venture into that hostile and challenging environment. However, the northwest divers do venture into the Pacific Ocean off the Oregon coast, and they love it.

The second chapter will feature some of the early diving pioneers that were attracted to the underwater world and bold enough to dive with minimum equipment, zero to minimum training, and no knowledge of what to expect when they entered the water at a dive site. We often refer to these pioneers as the "fearless and clueless" bunch.

The primary driving force for these divers, and many of the divers today, was (and is) fresh seafood. There is a tremendous abundance of tasty seafood to be harvested on the Oregon coast, including large rockfish and the huge lingcod.

The other motivation was the money a diver could make performing tasks underwater and recovering lost items.

The only formal diving education available in 1950 was for Navy divers. In 1960, the National Association of Underwater Instructors (NAUI) was officially formed to establish the first national standard for diver safety and education.

As more northwest diving instructors got involved with influencing the industry, new training techniques and innovative equipment designs were developed. Bill Herter, Deep Sea Bills in Newport, Oregon, and John Ratliff had an idea to create a double-layer wet suit jacket for buoyancy control.

Healthways and J.C. Higgins got into the game in the late 1950s as manufacturers of diving equipment. White Stag, an icon in Oregon located in southeast Portland, began making neoprene wet suits in the early 1960s.

As soon as three or more divers got together and began organizing their diving excursions, dive clubs were formed. It was not too complicated. The clubs just came up with catchy names and organized something each month or so. Most of the clubs created some competitive events and awarded trophies for the biggest fish, the most fish, the biggest octopus, the biggest abalone, or the most trash collected at a swimming beach.

One club in the area that formed in the 1970s was called the GBDT Dive Club. There were four guys who loved to spearfish and gather seafood. Their wives enjoyed the fresh seafood so much that they made up T-shirts for the husbands emblazoned with "GBDT Dive Club," meaning "Get Back Down There" and bring back more food.

Several clubs were formed around the theme of teaching diving, mentoring new divers, and enhancing diving safety. The Oregon Skin Divers Club was probably the first official club in Oregon. The Oregon Council of Dive Clubs was formed to establish communications with the small clubs around the state and to create some club competition for diving activities. Some dive clubs were organized for the purpose of public safety dive teams for search and rescue and, eventually, for underwater investigation and evidence recovery.

In 1950, there were not any dedicated dive retail stores, but there were lots of military surplus stores and a few of those set up high-pressure air compressors and began selling new and surplus dive gear and filling air tanks.

Tommy Amerman opened the first dive shop in Oregon around 1953. Don Hollingshead opened Eugene Skin Divers Supply in 1956. Jerry Hiersche established Underwater Sports on Southeast Sixty-Fifth Avenue and Powell Boulevard in Portland about 1965

In Newport, Oregon, Bill Herter added scuba gear and set up an air compressor at his fishing supply store, Deep Sea Bills.

At the time of this writing, Astoria Scuba is the only full-service, year-round professional dive store on the Oregon coast. It is located at Pier 39 in Astoria, at the mouth of the Columbia River, commonly known as the "Graveyard of the Pacific."

The Oregon coast is celebrated for its historical and geographical blend of a small chunk of Pacific Ocean, coves, cliffs, forests, and coastal mountains. A destination point for cold-water divers of all abilities, it is known for scuba training, coastal harvesting, and exploration.

Near Astoria is the South Jetty of the Columbia River. This site is located on the tip of the South Jetty at the mouth of the mighty Columbia River and is an intermediate-to-advanced dive site. Accessible by boat only, it is well known for spearfishing lingcod, Dungeness crab, and occasional wreck diving for those divers with extreme wreck certifications.

To the south is Tillamook Head and Tillamook Lighthouse, a great site accessible by boat only.

Farther south are Netarts, one of the favorite local dive club areas; it has several basic and advance dive spots; then the crab dock, a great site for, what else—crabs; and then the Wacoma/NOAA dock, another great place to grab a few crab for dinner.

Then one can head to Newport and the south jetty to dive the Fingers, probably the best known dive in the Newport area, followed by a visit the Oregon Coast Aquarium while in the neighborhood.

Yaquina John Point, located in Waldport, has the best crabbing in the area. Next is the Siuslaw River, another excellent place for crab, followed by the crab dock at Winchester Bay, a nice location for just about everything.

Now on to Nellie's Cove at Port Orford, a very quiet area away from the northern and western exposure of the Pacific. This is a good spot for beginner diving, as well as an easy location to check out equipment before heading to more advanced sites.

The rocks and reefs offshore from Port Orford are spectacular. On south toward Brookings, there are the Whales Cove and the Twin Rocks sites.

These are just a few of the named locations, but the entire coastline has excellent diving when one has a good dive vessel. Inflatables are great, as are larger vessels that are set up for diving.

One

THE ATTRACTION TO THE OREGON COAST UNDERWATER WORLD

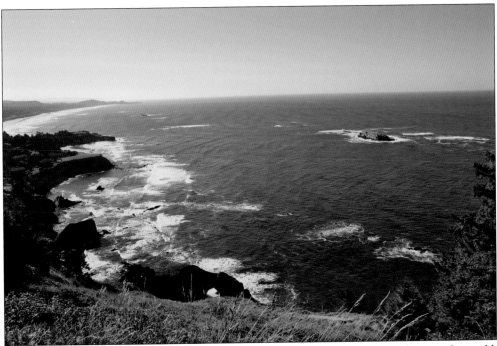

The Oregon coast is well known as one of the most beautiful and rugged coastlines in the world. The crashing waves from the Pacific Ocean have carved the coastline to create thousands of submerged reefs and exposed rocks that stick out of the water in defiance of the constant punishment from the Pacific Ocean. This photograph provides a small glimpse of the grand views that visitors come to see. (Courtesy of Jim Burke.)

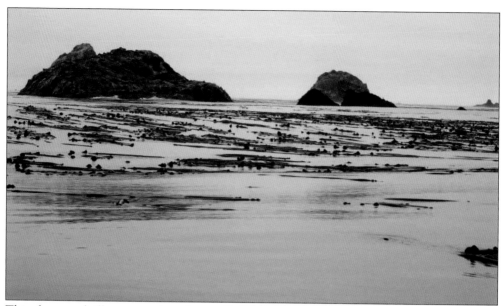

This photograph illustrates a giant forest of bull kelp, the common name. Non-divers look at the kelp and envision an entanglement hazard. Divers get excited when they find the kelp just lying around like this, because they can tell that there is no current or, perhaps, a mild and manageable current. This is a promising day to dive and there will be some great subjects to photograph. (Courtesy of Jim Burke.)

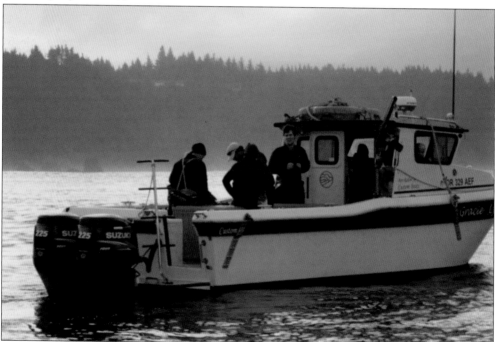

The dive vessel in this photograph belongs to the Oregon Coast Aquarium. These divers are on a mission to conduct biological research or collect specimens for the aquarium. They also conduct archaeological research and searches for sunken vessels, some of which have been underwater for many decades, perhaps even from the 19th century. (Courtesy of Jim Burke.)

Seen here is the Oregon Coast Aquarium in Newport, Oregon. The aquarium's *Passages of the Deep* exhibit allows the visitor to literally immerse themselves in the ocean realm that exists right off the Oregon coast. A series of underwater walkways leads the visitor from the Orford Reef, through the teeming waters of Halibut Flats, and finally into the vast blue expanse of the open sea. (Courtesy of Lance Beck.)

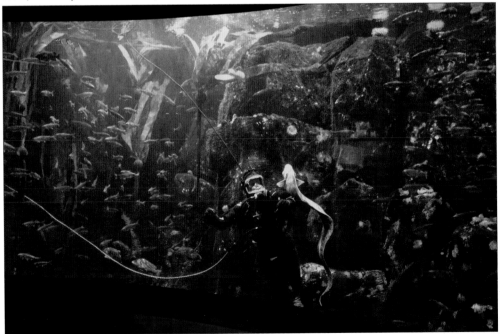

This is what it looks like inside the Oregon Coast Aquarium. This diver is using a full-face mask with voice communication so she or he can visit with the viewers while feeding some of the fish, including the friendly wolffish (commonly called wolf eel). Whether one is a diver or not, the aquarium tour and experience is always rewarding. (Courtesy of Jim Burke.)

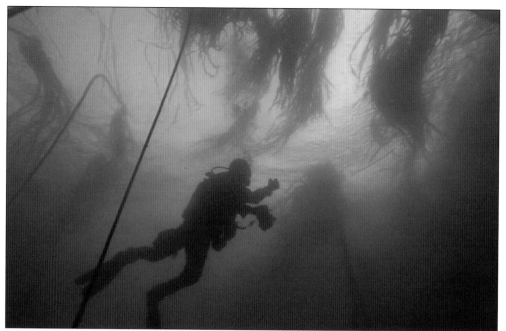

This photograph shows a diver with a camera venturing under the canopy of the bull kelp. Swimming through the kelp is intimidating at first, but after a couple of dives and learning that the kelp is one's friend, it is very enjoyable. It is where divers can find the most marine life—especially the small, colorful fishes and invertebrates. (Courtesy of Floyd Holcom.)

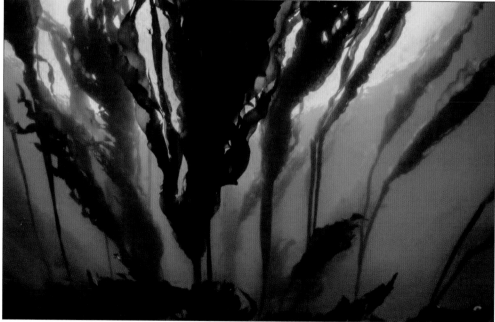

This image was captured in the kelp, when the photographer was looking for the best path through the forest. The thick top layer of blades, attached to a gas-filled ball, provides the canopy that is seen from the shore. But under the canopy, there is a colorful wonderland full of a wide variety of marine creatures. (Courtesy of Jim Burke.)

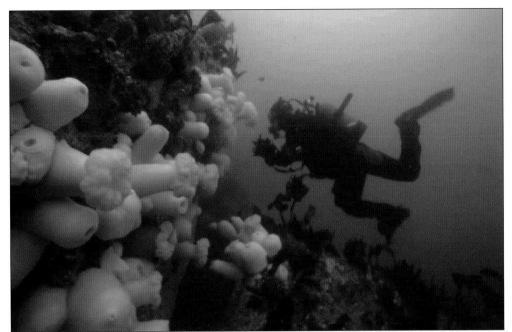

This photograph shows a diver a little deeper on a reef that is loaded with a field of large, white, plumose anemone, one of the largest species of anemone in the world. This diver carries an underwater camera and looks for subjects to capture on film or digitally. Underwater photography is a very popular diving activity. (Courtesy of Jim Burke.)

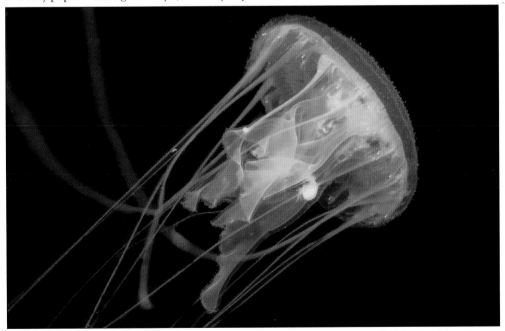

It is quite common to jump into the ocean and find oneself looking at a jellyfish—and sometimes, a whole bunch of jellyfish, commonly called a "bloom," or "swarm." Because they are light-colored and mostly translucent, it is difficult to see them from the boat while looking into the water before taking the plunge. (Courtesy of Steve Zedekar.)

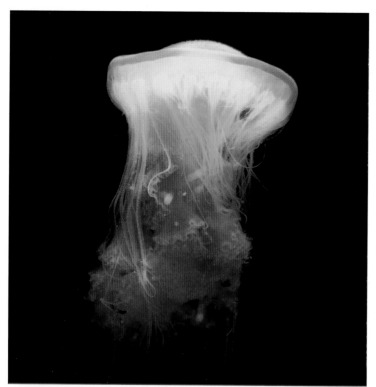

This photograph shows a common Pacific Coast jellyfish called the lion's mane. They can get quite large and have a pretty strong sting if the tentacles touch bare skin. Divers learn to brush off their gloves really well after exiting the water if they have come in contact with this or any jellyfish tentacles. (Courtesy of Steve Zedekar.)

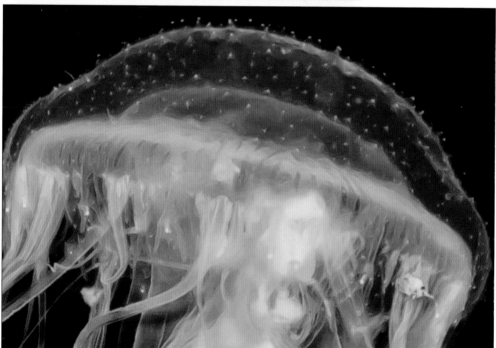

This is a unique shot because there appears to be a small grunt sculpin in the tentacles of this jellyfish. It is hard to tell if the little fish is captured and going to be consumed or it is there to get some scraps of something larger that the jellyfish will consume. (Courtesy of Steve Zedekar.)

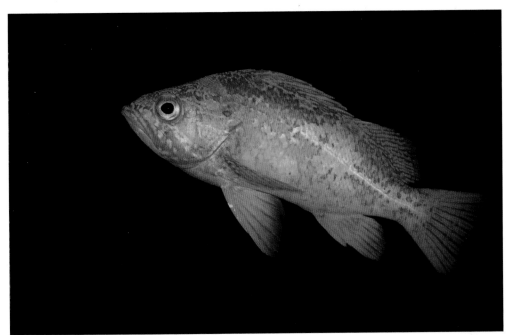

This photograph shows a vermilion rockfish, a very pretty species found up and down the Pacific Coast. These fish hover above and around the rocky reefs, under the kelp and deeper in canyons, where they can find food and places to hide from larger predator fish, such as the lingcod. (Courtesy of Steve Zedekar.)

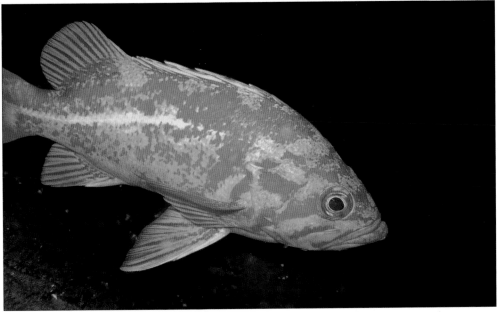

This vermilion rockfish looks more bright red than the orange color of the one in the previous photograph. The color difference is actually a result of the distance the light is from the subject. As light penetrates water, colors are lost in the order of the spectrum, like a rainbow: red, orange, yellow, green, blue, indigo, and violet. Undoubtedly, the light is closer to this fish. (Courtesy of Steve Zedekar.)

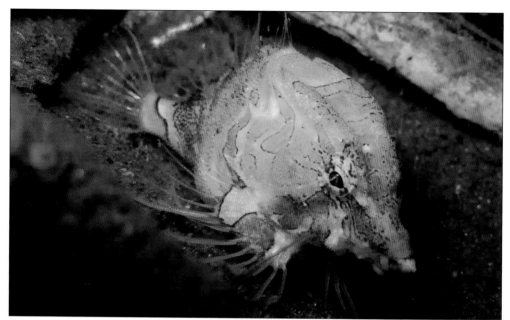

This is a cute little grunt sculpin, found on the bottom and usually hiding. These fish make a wheezing and grunting sound when removed from the water, hence the name *grunt sculpin*. Scuba divers say the grunts can be heard underwater. The coloration of these fish camouflages them in their preferred habitats. Hiding in an empty barnacle shell with only its snout protruding, it resembles a closed barnacle. (Courtesy of Steve Zedekar.)

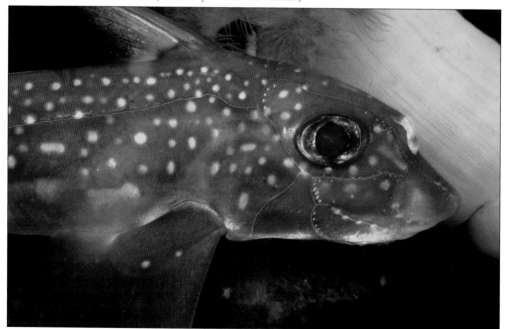

The spotted ratfish is believed to have evolved from sharks 400 million years ago. They resemble sharks in that they use claspers for internal fertilization of females and lay eggs with leathery cases. They do not have sharp and replaceable teeth like sharks have; instead, they have just three pairs of large permanent grinding tooth plates. (Courtesy of Steve Zedekar.)

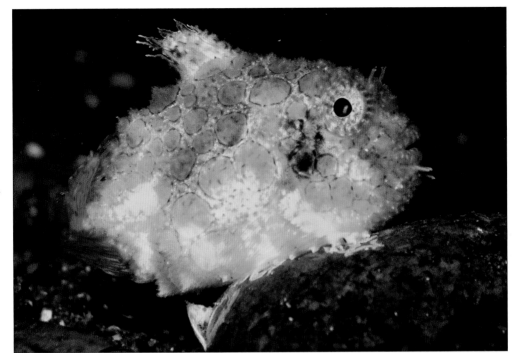

The Pacific spiny lumpsuckers are a favorite of scuba divers. In addition to their entertaining movements and behaviors, they often will eat out of a diver's hand. Pacific spiny lumpfish have an almost spherical or global head and body shape. They do not have scales; instead, the body is covered with platelike structures containing spiny lumps called tubercles. They are tiny, from one to three inches in length. (Courtesy of Steve Zedekar.)

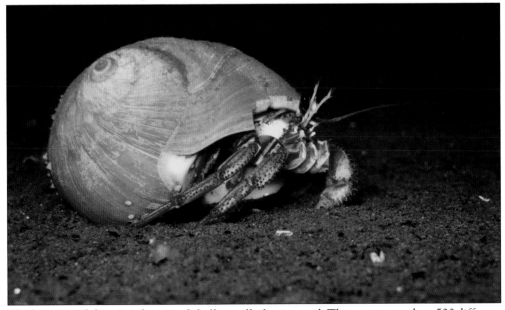

The hermit crab lives in a borrowed shell, usually from a snail. There are more than 500 different species of hermit crabs. Some live on land, but most live in the ocean. When a crab gets too big for its shell, it leaves and finds another one that is larger. (Courtesy of Steve Zedekar.)

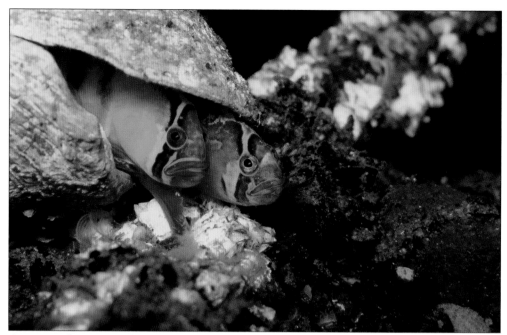

A mom and pop pair of gunnels snuggle together in a reef with barnacles below. It is always a treat to find a pair of fish together like these two. There are lots of different species of rockfish and cod that make the Oregon coast reefs home, along with octopuses, abalones, scallops, and many more marine creatures. (Courtesy of Steve Zedekar.)

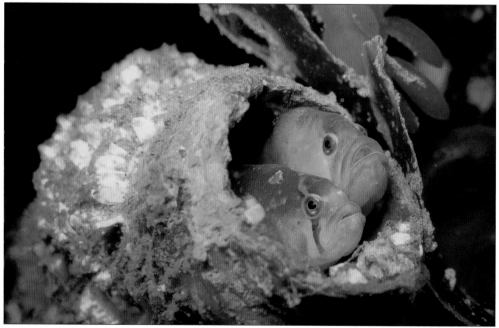

Here is another cute pair of gunnels just hanging out on their front porch, perhaps looking around for something to come by that they can eat or keeping an eye out for predators that want to eat them. Getting close to take a photograph like this takes great skill. When disturbed, this pair will instantly back down into their protected home in the reef. (Courtesy of Steve Zedekar.)

A master of camouflage, this little reef fish, a warbonnet, really blends in with the surrounding environment. Most divers do not see these little fish because they are hard to spy unless one is moving along very slowly and really paying attention to the small openings in the reef. (Courtesy of Steve Zedekar.)

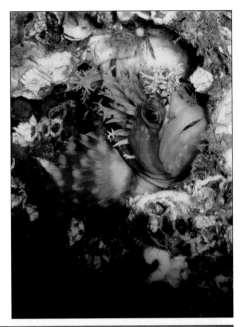

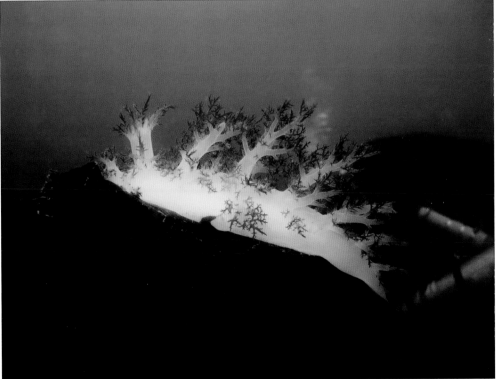

The next few photographs feature nudibranchs, which are soft-bodied, marine mollusks without a shell like their relatives, clams and oysters. This photograph shows a red dendronotid, an opalescent nudibranch, one of about 3,000 species known so far. The term *nudibranch* means "naked gills," indicating that the animal's gills are exposed and not inside a shell like other mollusk relatives. (Courtesy of Steve Zedekar.)

This translucent nudibranch, a white-lined diruna, is grazing over the top of what appears to be a large clamshell and is perhaps heading for the rocky bottom below for more food. Many people refer to these creatures as sea slugs, and they may resemble the slugs found in one's garden—although they are a lot prettier. (Courtesy of Steve Zedekar.)

This photograph shows a translucent, red-gilled nudibranch with egg cluster. Nudibranchs are hermaphroditic (having a set of reproductive organs for both sexes), but they cannot fertilize themselves. They typically deposit their eggs within a gelatinous spiral. Swimming across this one with the eggs is a very rare find. (Courtesy of Steve Zedekar.)

This photograph features a sea lemon nudibranch, which is common on the Pacific coast from British Columbia, Canada, to Baja California, Mexico. They live at depths from tide pools to 750 feet. They are bright yellow and one of the largest species of nudibranch, growing to about 10 inches long. (Courtesy of Steve Zedekar.)

This leopard nudibranch is aptly named, as the brown rings that usually dot the body create a definite leopard-print look. This species has a slightly gritty texture and is solid to the touch. They are most often seen feeding on sponges, their main diet. This is a very common nudibranch off the Oregon coast and has a range from Japan to Alaska to Baja California. (Courtesy of Steve Zedekar.)

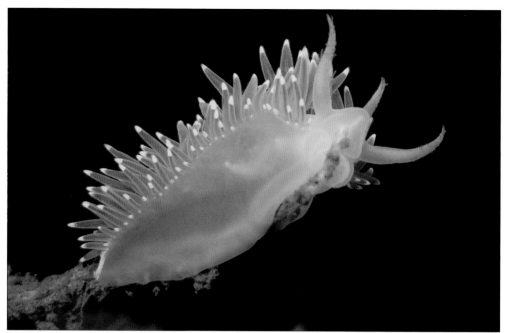

This opalescent, white-tipped nudibranch may have a surprise for predators. When this species of nudibranch feeds on a sea anemone, it ingests the toxin that is inside the tentacles of the anemone and is able to reuse that toxin to defend itself. Otherwise, the nudibranch has no other defense. (Courtesy of Steve Zedekar.)

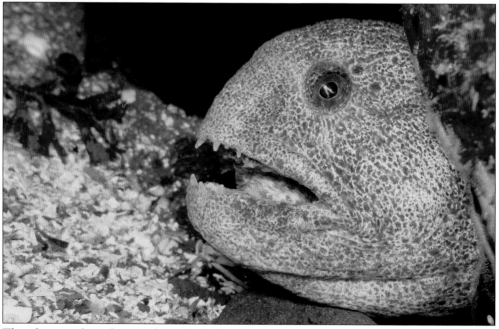

This photograph is of a juvenile wolf eel, which divers do not see very often. Young wolf eels live on the surface of the water until they are around two years of age, and then they migrate into the depths and live in caves or cracks in the rocky reefs, where they establish their dens. The life span of a wolf eel is about 25 years. (Courtesy of Steve Zedekar.)

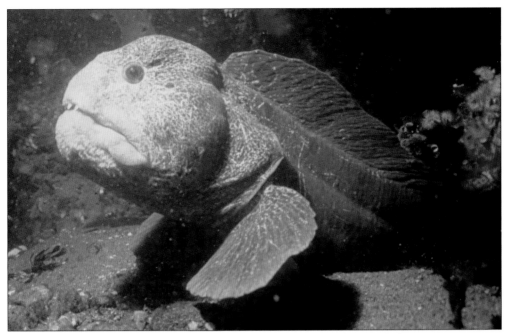

This adult male wolf eel has come out of its den to investigate the diver with the camera. He is not looking to get his picture taken; instead, he is hoping that the diver will assist him with his quest to get some food, specifically a spiny sea urchin. The diet of the wolf eel consists of crustaceans, sea urchins, mussels, clams, and an occasional fish. (Courtesy of Tom Hemphill.)

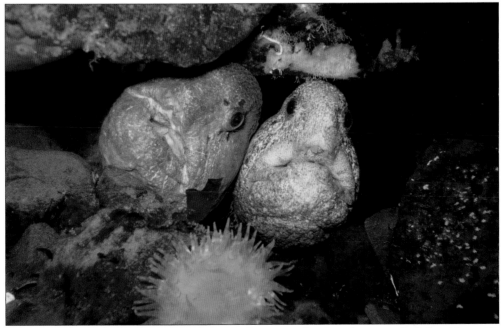

Here is a cute couple: mom on the right, with the narrow head, and pop on the left, with a wide head and a bit larger. A male and female pair up at about age four and live together in their den. They begin to reproduce at age seven, and the female lays approximately 10,000 eggs. (Courtesy of Steve Zedekar.)

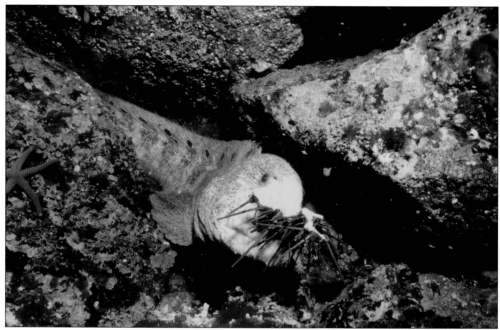

This guy is enjoying a treat, compliments of the diver taking the photograph, who chopped up a spiny sea urchin and offered it to a friendly wolf eel. Sure, the wolf eels can get the urchins open by themselves, but they sure seem to appreciate it when a diver does it for them. (Courtesy of Tom Hemphill.)

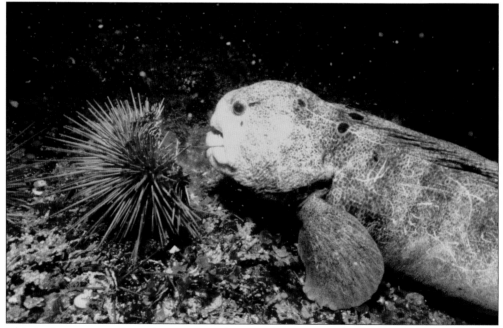

This is the same guy from the previous photograph, now completely out of his den to get to the other half of the cracked-open spiny sea urchin offered by the diver. Divers find it to be no problem petting a friendly wolf eel. They seem to like it and are not intimidated at all. (Courtesy of Tom Hemphill.)

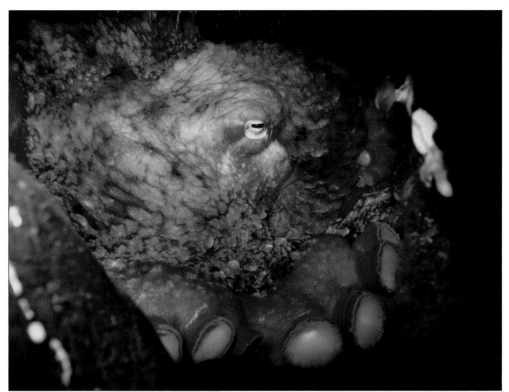

This image looks into the eye of a giant Pacific octopus, another den dweller. In fact, they can compete with the wolf eel for a good reef condo. The octopus is in the phylum Mollusca, related to squids and shellfish, such as clams, oysters, and scallops. Octopuses are ranked as the most intelligent invertebrates. They have demonstrated the ability to recognize specific persons. (Courtesy of Steve Zedekar.)

This is a small red octopus roaming around the reef looking for a meal. They will eat most anything, such as fish and clams, but their primary prey are crabs. Crab is what divers feed them to make friends and get them to pose for pictures. The giant Pacific octopus has a lifespan of three to five years. (Courtesy of Steve Zedekar.)

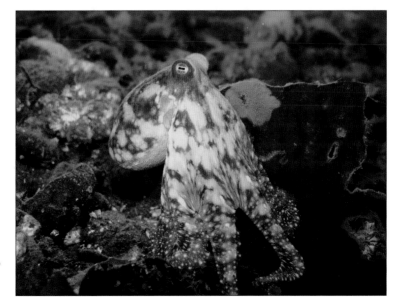

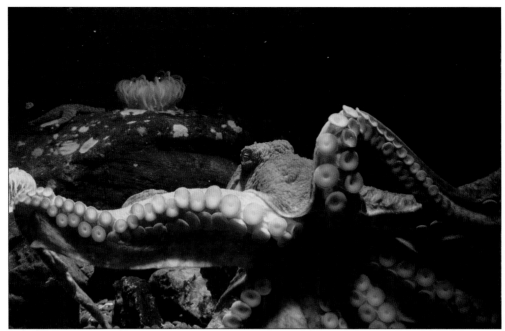

Here is a much larger Pacific octopus. This one may weigh 40 pounds or so. The largest on record weighed in at 156 pounds and may have had a span of 30 feet from tip to tip of the tentacles when fully spread out. The suckers on this one may be more than one inch in diameter, and the really big guys have suckers that reach two-and-a-half inches in diameter. (Courtesy of Lance Beck.)

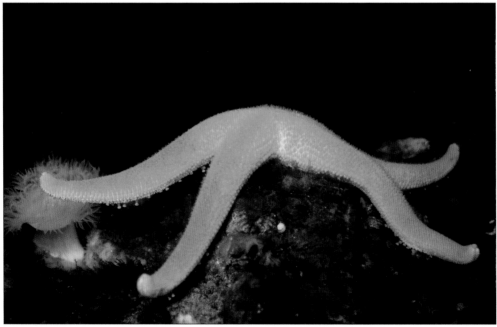

This photograph is of a common orange sea star (starfish). While diving, it is necessary to use a bright light; in the case of photography, a strobe flash is used in order to get the true colors to show. As divers descend, the first color lost in just a few feet is red, followed by orange. If a light were not used, this sea star might appear green or blue or gray. (Courtesy of Steve Zedekar.)

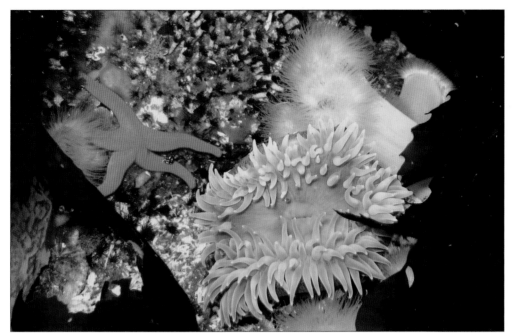

This photograph shows a diverse ecosystem with a reef full of feather duster tube worms (all sucked into their tubes, having been disturbed by the photographer), some broad-leaf kelp, several white Metridium anemones, a green anemone, and of course, the red sea star. Again, the diver's strobe brings out the colors for this photograph. (Courtesy of Steve Zedekar.)

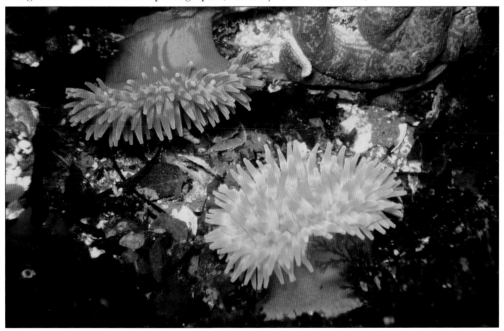

This is another look at the reef covered by all sorts of creatures, including the beautiful anemones, which are carnivorous animals that eat small fish, and a large sea star at the top right of the photograph. Anemones are related to corals and have stinging cells that sting fish who get into the tentacles; they are then taken down the center mouth to be digested. (Courtesy of Steve Zedekar.)

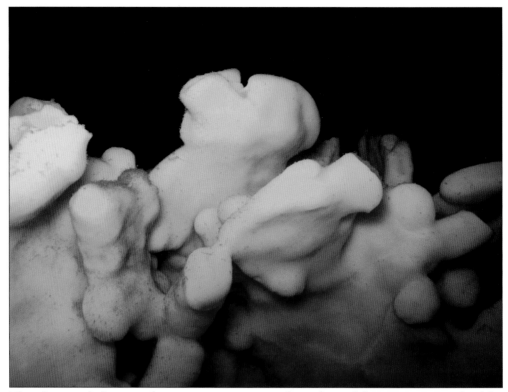

This photograph features a large sponge growing on the rocky reef. Sponges are animals of the phylum Porifera. They are multicellular organisms that have bodies full of pores and channels allowing water to circulate through them, consisting of jellylike mesohyl sandwiched between two thin layers of cells. Many marine animals make their homes inside and around the sponges, such as small fish and shrimp. (Courtesy of Steve Zedekar.)

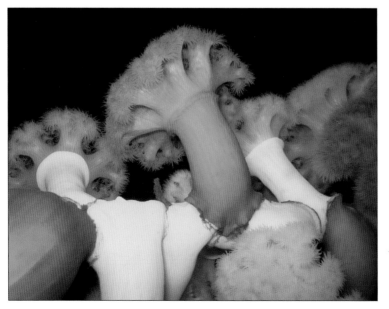

Here again is a giant field of Metridium anemone. They certainly appear as large flowers, but they are actually carnivorous animals. They will sting some animals and eat them; however, there are some marine animals that are not affected by the sting, so they live in harmony with the anemones. (Courtesy of Steve Zedekar.)

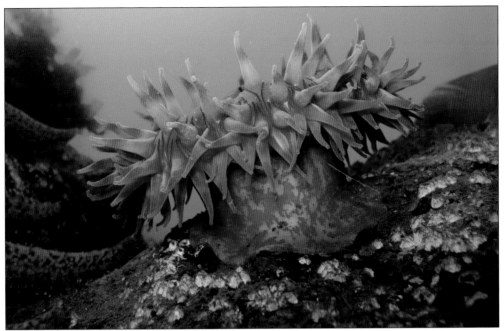

This is another brilliant red anemone. Anemones tend to stay in one spot unless the conditions are unfavorable, such as a predator attacking them. Although they rarely move, they do have the ability to uproot themselves and actually swim to a new location. Some species are free-swimming, but not this one. (Courtesy of Steve Zedekar.)

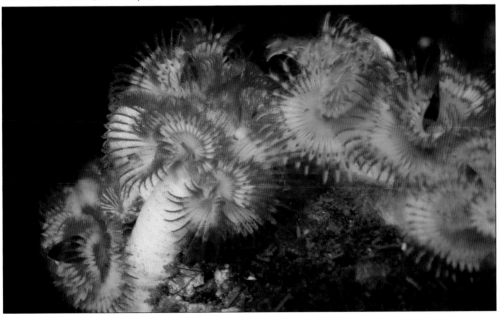

Illustrated here is the feather-duster tube worm in the phylum Annelida. They have a crown of feeding appendages in fan-shaped clusters that are used as filter feeders, dependent on food that drifts by in the current. What makes these animals difficult to photograph, and irritating as well, is their ability to sense danger and instantly draw their beautiful feathers down inside of the tube. (Courtesy of Steve Zedekar.)

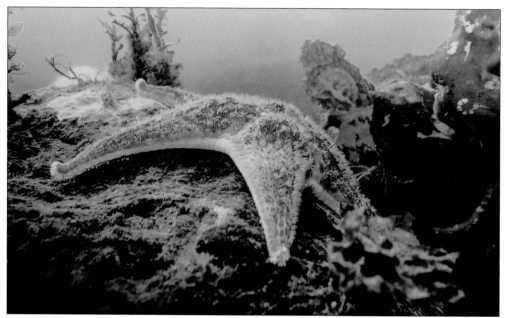

Starfish are not fish, as they do not have gills. They do have lots of tube feet that are used to walk around the reef, looking for food and to attach to the reef, a piling, or sunken vessel. Most starfish species have five arms; however, the large sun star can have as many as 40 arms. Other relatives that have five segments include sea cucumbers, sea urchins, and sand dollars. (Courtesy of Steve Zedekar.)

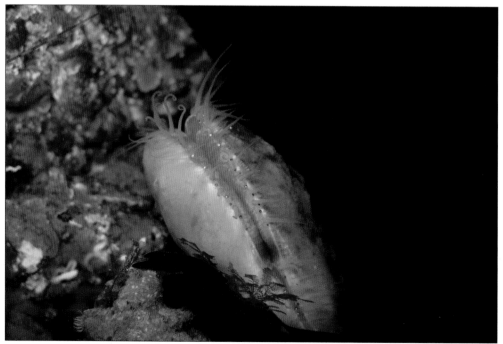

Here is a small swimming scallop that is not solidly attached to the rocks and can open and close to force water out and jet a short distance. Note the row of little eyes. The large rock scallops that can get as large as a dinner plate are solidly attached to the rocky reef. (Courtesy of Steve Zedekar.)

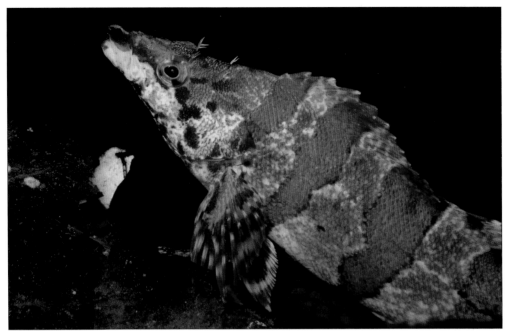

The small fish pictured here is a painted greenling, identified by its elongated head, pointed snout, and dark vertical bar coloring (usually red) with a white body. It is common to find these small fish lying amongst the tentacles of a sea anemone with stinging cells, which do not affect the painted greenling. This is called symbiosis, when two animals live together in harmony and provide some benefit for each other. (Courtesy of Steve Zedekar.)

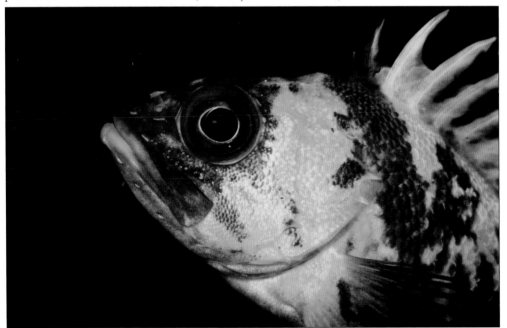

This photograph shows a copper rockfish. This species can grow to be larger than 26 inches and live for more than 50 years. These fish are common, and divers see them around the rocky reefs, cruising through a kelp forest and sometimes schooled above a reef midwater. (Courtesy of Steve Zedekar.)

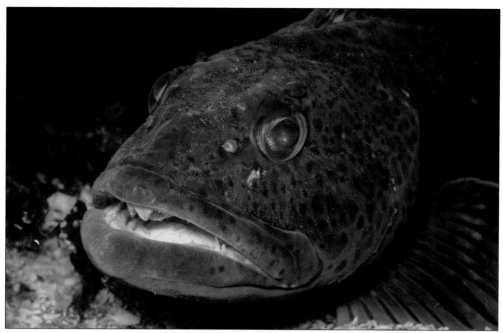

Here is a close-up photograph of the head of a lingcod. When doing an Internet search for lingcod, most of the results are for seafood restaurants and recipes, as the lingcod is one of the best-tasting bottom fish. It is interesting to note that sometimes the meat of the lingcod is blue-green to turquoise, but when cooked, it turns white. (Courtesy of Steve Zedekar.)

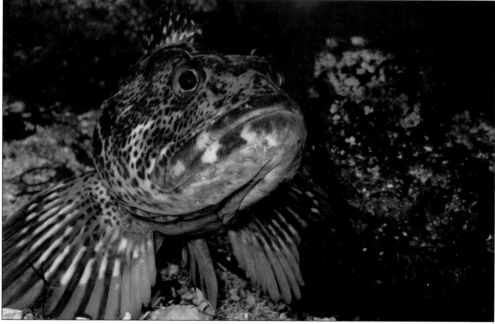

Pictured is another close-up of a lingcod. Divers often see the big "lings" lying on the bottom overlooking a ledge and searching for small fish to eat. A common-sized ling off of the Oregon coast may be 30 inches long and weigh 40 pounds. Some reports claim that lings have been taken that are five feet long and 130 pounds. (Courtesy of Steve Zedekar.)

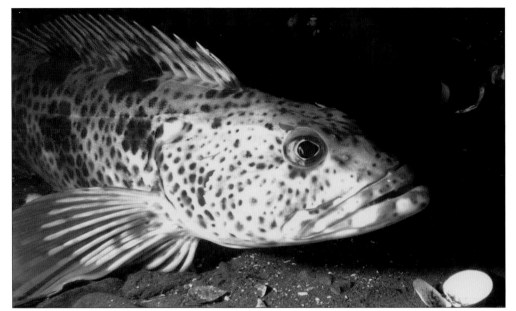

This ling lies on the bottom; however, it is not unusual to see a big ling cruising through the upper blades of a kelp forest. They will go wherever they can to find a meal. In the late fall, the male ling will establish a nest, and then the female lays a large cluster of eggs, sometimes as many as 500,000. The male then guards the eggs until spring, when they hatch. (Courtesy of Steve Zedekar.)

This photograph is of a very interesting little blenny called a mosshead warbonnet, who is camouflaged well. Divers must explore very slowly and carefully in order to find some of the inhabitants throughout a reef ecosystem. There are lots of places to hide, and many of the reef creatures get protection from just being hard to find. (Courtesy of Steve Zedekar.)

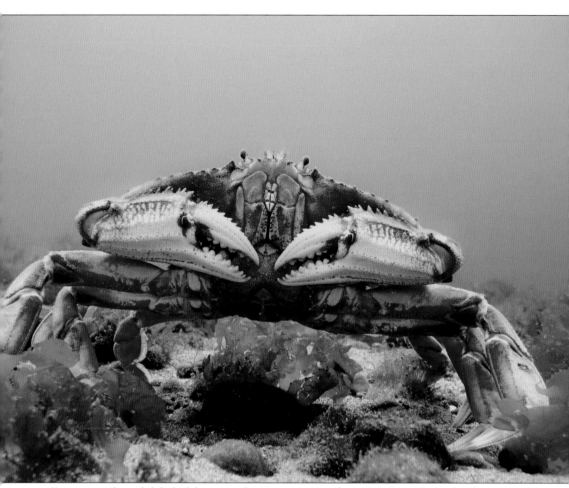

Fun to watch and delightful to eat, the Dungeness crab is abundant along the Oregon coast. As one can see by the narrow part on the underside, this is a male and legal to take if it is large enough. It is important to check the game laws, as they may change from year to year. (Courtesy of Steve Zedekar.)

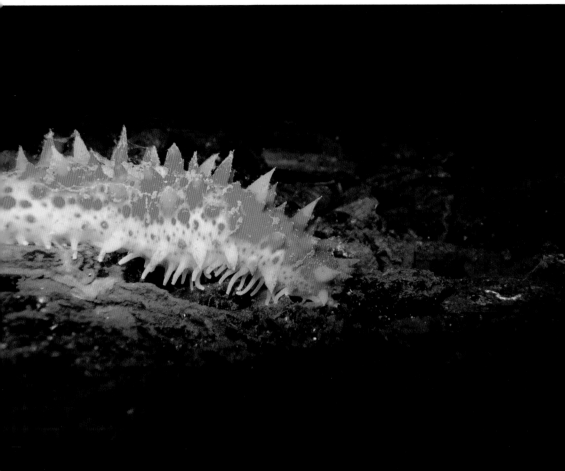

This is a good shot of a sea cucumber, an echinoderm that is related to starfish and sea urchins. Divers see these animals on the reefs and the sandy or mud bottoms. One interesting fact about sea cucumbers is that some species live very deep, up to more than five miles below the surface of the ocean. They are also good to eat. There are five strips of meat inside that make a good chowder. (Courtesy of Steve Zedekar.)

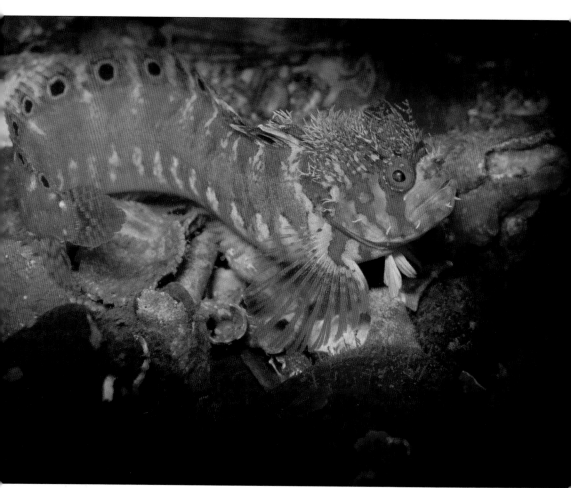

This brightly colored mosshead warbonnet has a great camouflage technique on its head. The bright colors are visible because the photographer used a strobe flash to bring out the true colors, but at depth, this little fish would blend right in with the surroundings. Divers, regardless of where they are diving in the world, take large dive lights with them so they can see the true colors at depth. The rocky reefs and giant kelp forests along the Oregon coast are home to hundreds of species of colorful fish, invertebrates, and plant life. Most of the residents hang out around the reefs, and some like the sandy or muddy bottoms as well. There are also pelagic fish that come to visit on occasion, such as albacore tuna, giant sunfish, and sharks. California gray whales migrate up and down the coast, as do orcas, also known as killer whales. Other popular residents to watch are seals and sea lions, though divers do not actually see them underwater very often. (Courtesy of Steve Zedekar.)

Two

DIVING PIONEERS

This is a photograph of Tommy Amerman, one of the diving pioneers in Oregon. Amerman opened the first dive shop in Oregon around 1953. He began renting masks, fins, and snorkels out of his living room. As the business grew, he moved the shop out of the house and into the garage. The shop was then later moved to Southeast Eighty-Second Avenue in Portland. (Courtesy of Sid Macken.)

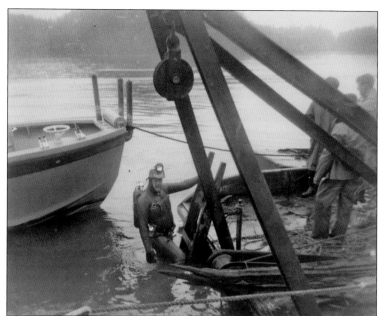

This photograph shows a "snag diver" near Astoria, Oregon, in the Columbia River. These divers, including Amerman, descend along a snagged net, or a cable that is hooked on a snag in the area of the net, fishing for salmon. They hook a cable onto the snag, usually a tree and root ball, so the fishermen can winch it up and out of the river. (Courtesy of Sid Macken.)

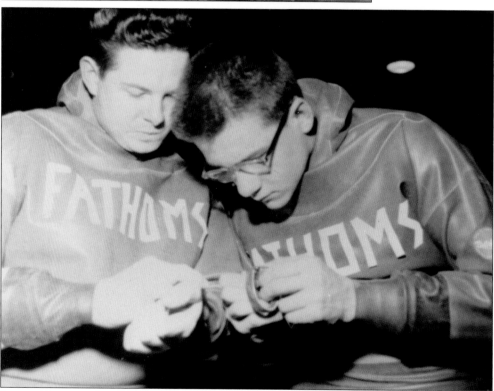

Pictured here are Gary Rubottom (left) and Jerry Hiersche, two of the first Oregon skin divers to buy scuba diving gear. Because there were no diving supply stores in Oregon, they drove to Los Angeles and purchased Aqua Lung regulators and compressed-air tanks. They got a one-hour lesson and were sent off to explore the underwater world. They survived. The photograph shows them repairing a dry suit. (Courtesy of Sid Macken.)

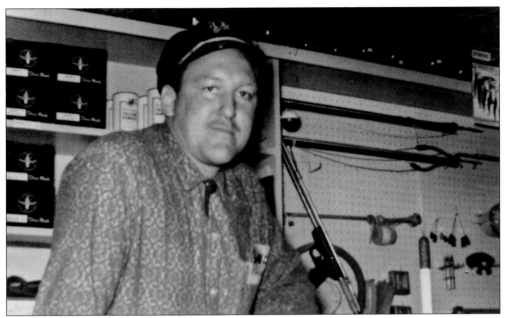

In this photograph is Bill Herter, owner of Deep Sea Bills in Newport, Oregon. Herter had a fishing supply business, and he added a compressor for filling tanks and a line of scuba equipment for sale. The shop soon became the primary destination for divers coming to the Oregon coast. Herter also began inventing new dive gear, such as a double-layer wet suit for buoyancy control. (Courtesy of Sid Macken.)

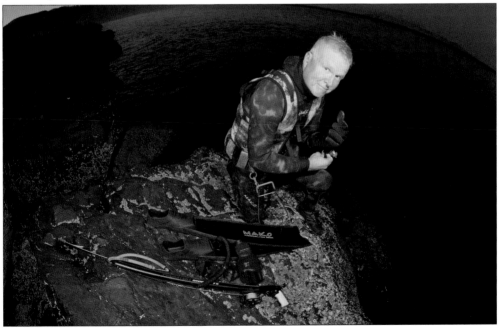

Tom Henderson is pictured here in 2015, still diving the Oregon coast. He learned to dive at age 13 in 1969 when he became acquainted with Tom Hemphill and some other divers who were on a club dive at the lake. Today, Henderson is an avid "free diver" and still loves to dive the Oregon coast and bring home fresh fish for dinner. (Courtesy of Josh Humbert.)

Here is Jerry Gray, the master sea storyteller, ocean scrounger, and great guy. Gray began diving in 1957 when he was in the Navy. He was certified as a NAUI instructor in 1965 and worked with Underwater Sports in Portland and Vancouver. Gray enjoyed diving for relics and found a lot—mainly old bottles but also ships bells, anchors, pottery, coffee mugs, and saucers, among other various items. (Courtesy of Al Beale.)

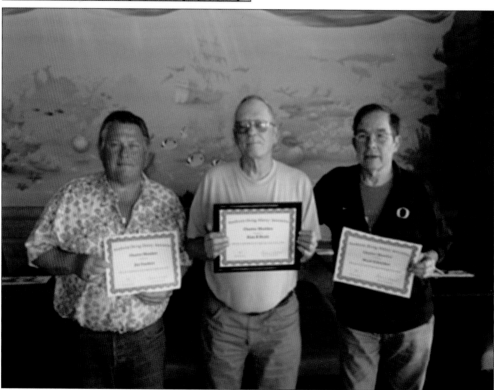

Pictured are three of the first charter members of the Northwest Diving History Association; from left to right are Jay Gardner, Al Beale, and Mark Schneider. Preserving Northwest diving history and sharing that history is the association's mission. Gardner, Beale, and Schneider were first in line to support this very valuable project. (Courtesy of Tom Hemphill.)

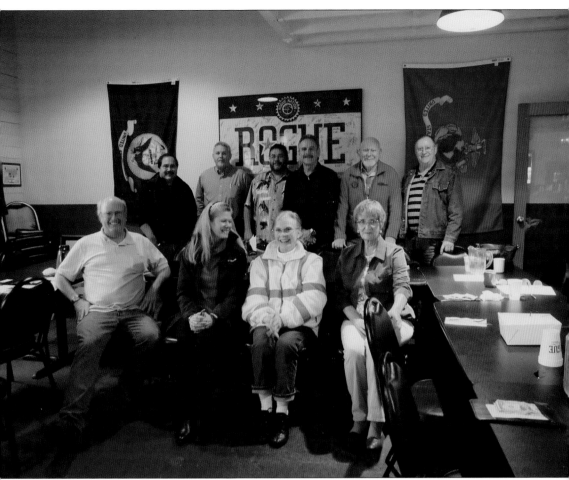

This image shows members of the Northwest Diving History Association, in Astoria for a planning meeting. From left to right are (first row) Jim Larsen, founding board member and NAUI representative in the Northwest region; Becky Witty, charter member; Zale Parry, founding member, diving historian, scuba equipment inventor, and star in the *Sea Hunt* TV series; and Sharon Reseck, charter member; (second row) Floyd Holcom, founding board member and diving historian; Sid Macken, president of the Historical Diving Society, a worldwide diving history organization; Jeff Groth, board member and historian; Dennis Lucia, founding board member and diving historian; John Reseck Jr., charter member, diving historian, and author; and Tom Hemphill, founding board member, chairman of the board, author, and diving historian. (Courtesy of Tom Hemphill.)

This is Floyd Holcom, owner of Pier 39 in Astoria and Astoria Scuba. Holcom is very proud to have the only full-service, year-round diving retail store and service center on the Oregon coast. He has received outstanding service awards from NAUI, and he trains professional diving instructors. Holcom is a retired Army Special Forces officer and a NAUI course director, with customers including Army, Navy, and US Coast Guard personnel. (Courtesy of Floyd Holcom.)

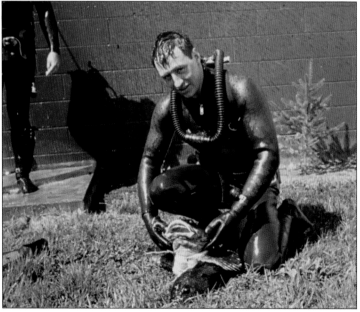

This is Tom Hemphill in 1967 with his first wet suit—a custom White Stag, skin rubber–lined, closed-cell, neoprene suit that required either talcum powder, corn starch, or dish soap to make it slick enough to get on. Hemphill was using an old double-hose regulator. He was also successful that day with bringing home some fresh dinner. (Courtesy of Tom Hemphill.)

Here are two old friends Tom Heinecke (dressed for diving) and Tom Hemphill. Hemphill was Heinecke's diving instructor in 1971 in Portland, Oregon. Heinecke became an instructor, and the two enjoyed diving and teaching together for a more than 10 years through the 1970s. This photograph was taken at a diving event October 11, 2015. (Courtesy of Tom Hemphill.)

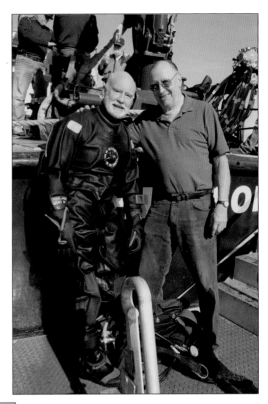

Pictured here is Paul Schorzman, cofounder in 1970 and eventual sole owner of the Diving Bell/Tri-West School of Skindiving. Schorzman taught classes at the store and at several other facilities, including Clark College in Vancouver, Portland Community College, Clackamas Community College, Mt. Hood Community College, and several other locations throughout the Portland area. (Courtesy of Paul Schorzman.)

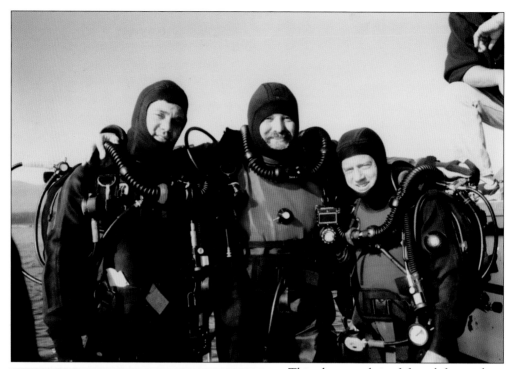

This photograph is of, from left to right, Brad Achmautz, Paul Schorzman, and Ron Tinker from Adventure Sports Scuba in Wood Village, Oregon. This photograph was taken as the three were on a boat trip and getting trained on rebreathers. Tinker bought Tri-West Diving from Schorzman in 1993. In 2013, he relocated the store to Wood Village, Oregon. (Courtesy of Ron Tinker.)

Ready to hit the water, John Ratliff is pictured with his prototype buoyancy compensator in 1971. Ratliff was a sport diver and NAUI diving instructor and research diver at Oregon State University. He worked with Bill Herter at Deep Sea Bills in his first try at building a double-layer wet suit jacket to hold air and adjust buoyancy. Later, Ratliff created his own prototype vest-style buoyance compensator (BC). (Courtesy of John Ratliff.)

Laurie Hannula is pictured in the early 1980s with the latest dive equipment at that time. Hannula began diving in 1977 and made a career of teaching and dive store operations, first in Vancouver at Underwater Sports and later as the owner of Pacific Watersports. Hannula was always eager to try new equipment, and she provided valuable feedback to manufacturers regarding new equipment innovations. (Courtesy of Laurie Hannula.)

In this photograph are a couple of wild characters: Roddy Winton (left) and Jon Hayes. Both of these men have been traveling up and down the coast for about 40 years, selling dive gear to retail stores, and they have loved their Oregon coast diving adventures. Winton relocated from Texas in the 1970s to represent TUSA (Tabata USA) and Hayes represents Oceanic; those are two of the leading diving equipment manufacturers. The men are competitors, but good friends as well. (Courtesy of Floyd Holcom.)

In front of Astoria Scuba are, from left to right, Jim Larsen, Jerry Osteremiller, and Christopher Dewey. Larsen is the NAUI representative in the Northwest, and he trains professional scuba instructors. Osteremiller is the former director of the Columbia River Maritime Museum and the discoverer of many shipwrecks off of the Oregon coast. Dewey is a retired US Navy officer and maritime archaeologist. (Courtesy of Floyd Holcom.)

In this photograph, Carl Monson (left) stands next to Jim Larsen (center) and Rob Evert, the new NAUI instructor at Astoria Scuba. These three dive instructors have nearly 100 years of experience diving the Pacific Northwest. Evert currently works at the Port of Astoria and has most recently moved from Carson, Washington, where he served on the sheriff's department dive recovery and rescue team. (Courtesy of Floyd Holcom.)

Three

DEVELOPMENT OF DIVING EDUCATION AND EQUIPMENT FOR COLD-WATER DIVING

In December 1951, *Skin Diver Magazine* was introduced as the "Magazine for Skin Divers and Spearfishermen." Neal Hess introduced a monthly column entitled the Instructor's Corner. The intent was to get "self-proclaimed" scuba instructors to submit the techniques they were using to teach scuba diving, which was very new to the United States. This began a nationwide dialog that established the foundation for standardized scuba training. (Courtesy of Tom Hemphill.)

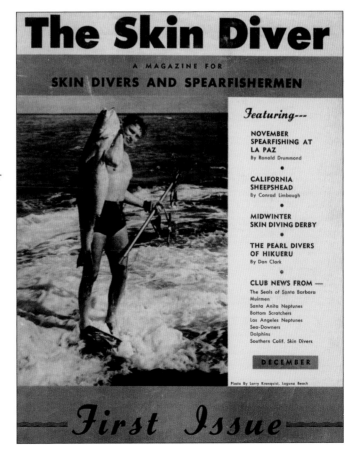

The Skin Diver

A MAGAZINE FOR
SKIN DIVERS AND SPEARFISHERMEN

Featuring---

NOVEMBER SPEARFISHING AT LA PAZ
By Ronald Drummond

CALIFORNIA SHEEPSHEAD
By Conrad Limbaugh

MIDWINTER SKIN DIVING DERBY

THE PEARL DIVERS OF HIKUERU
By Don Clark

CLUB NEWS FROM ---
The Seals of Santa Barbara
Muirmen
Santa Anita Neptunes
Bottom Scratchers
Los Angeles Neptunes
Sea-Downers
Dolphins
Southern Calif. Skin Divers

DECEMBER

Photo By Larry Kronquist, Laguna Beach

First Issue

This is an interesting ad to get skin divers to learn about scuba. Mel's Aqua Shop was owned by Mel Fisher, an American treasure hunter best known for finding the 1622 wreck of the *Atocha*. What can one learn about scuba diving in one lesson? Perhaps how to attach and detach the regulator, to not hold one's breath, and how to use the Navy dive tables to avoid the bends. (Courtesy of Tom Hemphill.)

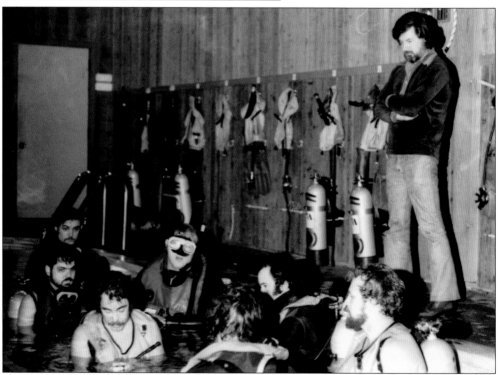

This photograph features Gary Rubottom (standing on deck) at the pool of Aquarius Underwater Center in 1971 overseeing a scuba class. Located on SW Barbur Boulevard in Portland, Aquarius Underwater Center was designed by Rubottom with a formal classroom, 12-foot-deep indoor pool, and large retail space. The primary theme of the business was tropical dive vacation travel, which was relatively new in the diving industry, especially for divers in Oregon. (Courtesy of Tom Hemphill.)

Scuba training has come a long way in its development, with e-learning, formal classroom lessons, pool (confined water) training, and extensive open-water training. The standards for teaching diving have also been developed over many years, since the beginning in 1951. In the classroom, students learn about diving physics, physiology, submarine medicine, marine environment, and equipment. (Courtesy of Rod Shroufe and Dan Semrad.)

Dan Semrad, co-owner of Scuba Specialties Northwest in Oregon City, a high school science teacher, and a NAUI instructor, has his students gathered around for some hands-on teaching of equipment. In this photograph, Semrad teaches about scuba cylinders and valves, going over the important stamping on the cylinders, the safety issues, and proper handling. (Courtesy of Rod Shroufe and Dan Semrad.)

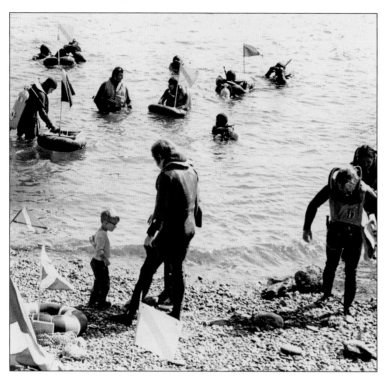

This photograph is of a typical open-water scuba training field trip in 1971. The equipment was a lot different then. However, by 1971, the standard for scuba training had progressed to requiring four to five supervised dives and a demonstration of a series of skills to teach and evaluate a new diver's proficiency before issuing a certification card. (Courtesy of Tom Hemphill.)

This is a photograph of Clark Wheaton in 1954 with a rubber neck-entry dry suit. Unlike the dry suits that are used today, this suit lacks a method of putting air inside. As the diver descended, the air inside the suit compressed, and the diver suffered from a painful suit squeeze, which caused water to leak through the seals around the neck and wrists. (Courtesy of Mark Wheaton.)

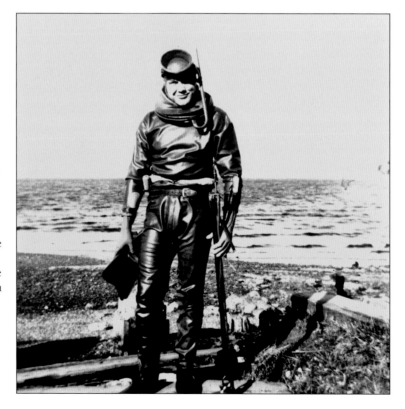

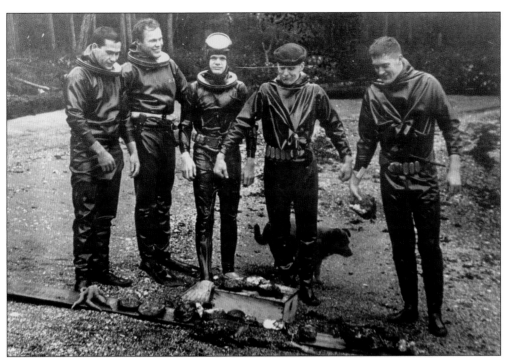

This photograph shows divers with two different types of dry suits. The three on the left have neck-entry suits, and the two on the right have front entry that required twisting the suit material and tying a knot to keep it dry. Neither suit was very dry, but it was better than no suit. The scallops and lingcod caught that day are also visible. (Courtesy of Mark Wheaton.)

Closed-cell, foam neoprene wet suits were developed in the early 1950s in California. White Stag, a Portland, Oregon, company, began making wet suits in the late 1950s or early 1960s. This illustration is a full-page magazine advertisement from 1962 for swimsuits and diving wet suits. White Stag expanded its diving line to include masks, fins, snorkels, regulators, and the rest of the gear needed for diving. (Courtesy of Tom Hemphill.)

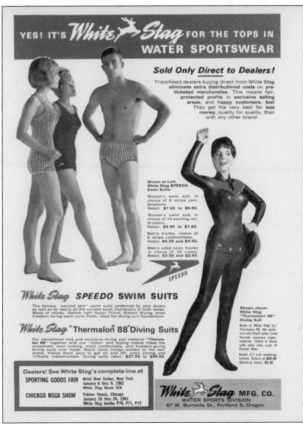

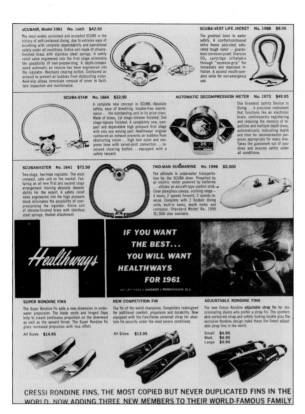

Healthways got into the manufacturing and distribution of scuba equipment in the late 1950s. Pictured here is a 1961 full-page magazine ad. The Cressi Rondine fins and the decompression meter were made in Italy and imported by Healthways. Healthways was a supplier and sold to various stores, including Sears and Montgomery Ward. (Courtesy of Tom Hemphill.)

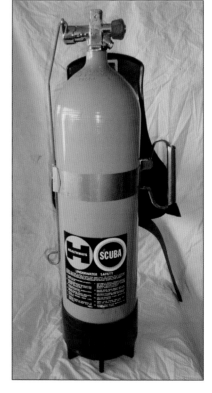

This Healthways scuba cylinder was new in 1966. Healthways bought the cylinders from another company and then had them tested and painted before affixing the company's decal, which includes some safety instructions. This was the standard outfit in 1966. This was also the standard size of a scuba cylinder, at 71.2 cubic feet. For most divers, this was plenty of air for a dive before they got too cold. (Courtesy of Tom Hemphill.)

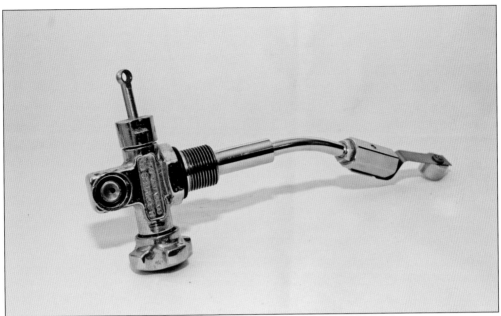

The first scuba systems did not have pressure gauges. Equipment manufacturers soon realized the problem and began to make valves with a reserve lever, as seen in the image of the yellow scuba tank. The valve in this photograph has a hammer inside the tank that begins to vibrate and bang the tank when the pressure is low, warning the diver (which can be very annoying). (Courtesy of Tom Hemphill.)

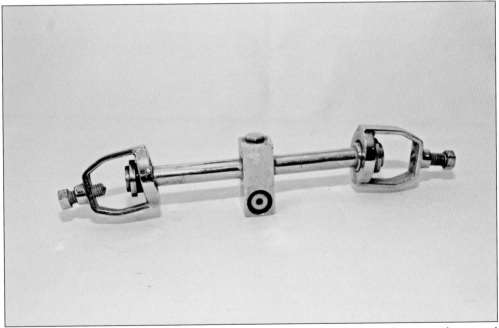

The single tanks were fine, but sometimes a diver wanted to stay underwater longer, so this special manifold was developed to connect two scuba tanks together to create a set of double tanks, thus giving the diver twice as much air for deeper dives and longer duration. This was especially beneficial for the working divers and photographers. (Courtesy of Tom Hemphill.)

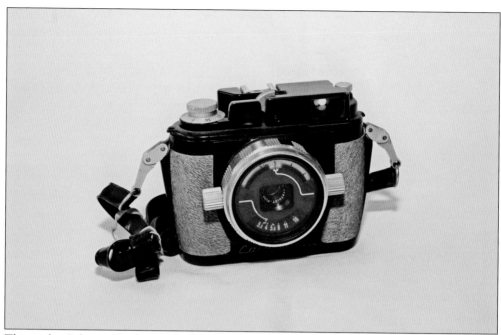

This is the Calypso, the first underwater camera conceived by Jacques Cousteau, developed by a company in France in 1960. Nikon took over in 1963 to make the Nikonos I then Nikonos II, III, IV, and V. During this same time, other companies began making waterproof housings for just about any popular land camera. (Courtesy of Paul Schorzman.)

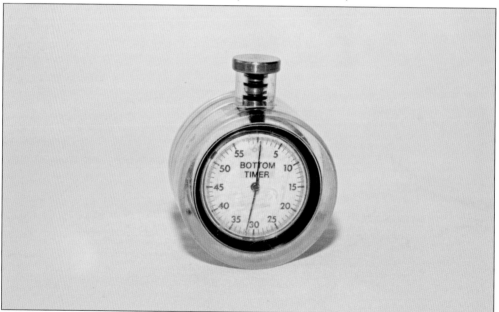

Information and control is crucial for diving safety, and accurate time under pressure is one of the bits of information a diver needs. This innovative piece of equipment is a pressure-activated timer, appropriately called the bottom timer. Dive watches worked, but the diver needed to set the bezel at the right moment, which rarely happened. This timer starts automatically when the diver descends. (Courtesy of Paul Schorzman.)

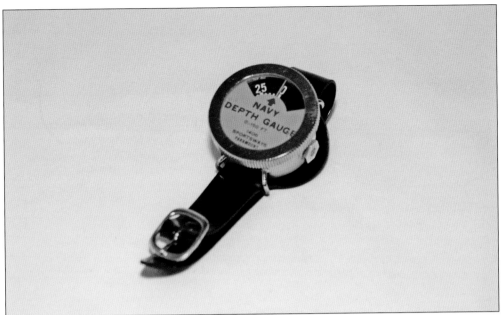

Depth during the dive is also an important bit of information. The gauge shown in this photograph was made for the US Navy by Sportsways Corporation, one of the leading manufacturers of diving equipment in the 1960s and 1970s. This gauge has a Bourdon tube mechanism with a tiny hole in the side to let water pressure inside, which moves the tube and the dial. (Courtesy of Paul Schorzman.)

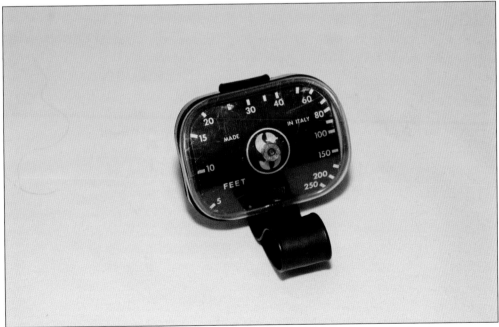

The depth gage pictured is a capillary-type gauge. There is a clear plastic tube that is open at one end. As a diver descends, water enters the open end and compresses the air inside the tube. As the air compresses, the water follows, and the diver can see where the waterline is. The gauge is calibrated to pressure/depth based on where the waterline is. (Courtesy of Paul Schorzman.)

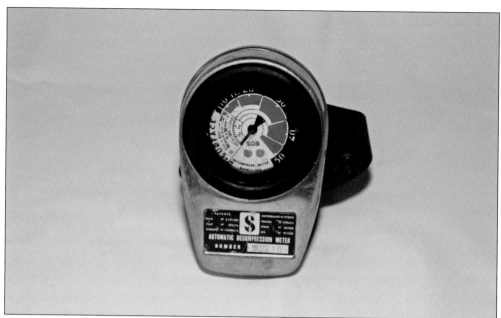

One of the first attempts at better control and preventing the dreaded bends was the introduction of the automatic decompression meter, first developed in Italy in 1959 by SOS Diving Equipment. In the United States, Healthways began distributing the meter under its brand, and ScubaPro later branded the meter. This meter was quite popular until dive computers were developed. (Courtesy of Paul Schorzman.)

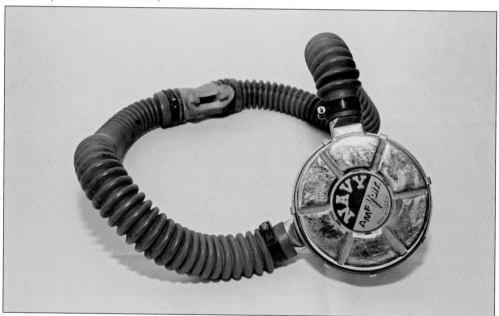

This photograph shows a 1960s version of the classic double-hose regulator made in France and imported to the United States with the Voit brand. Voit was one of the first five brands in the United States to sell scuba equipment. The double-hose regulator was the standard for the US Navy, until Voit had the single-hose MR12 approved by the Navy in the mid-1960s. (Courtesy of Paul Schorzman.)

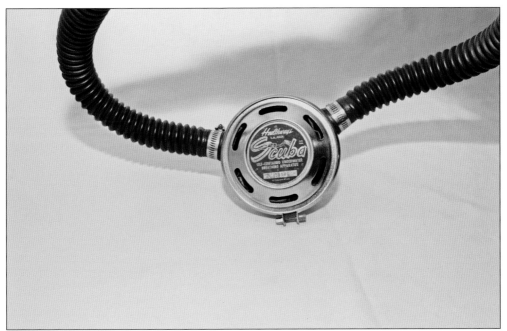

This photograph shows a Healthways double-hose regulator from the early 1960s. Like Voit, Healthways was one of the first five brands of scuba equipment in the United States. Healthways was a distributor and sold to small dive retailers as well as Sears and Montgomery Ward. (Courtesy of Paul Schorzman.)

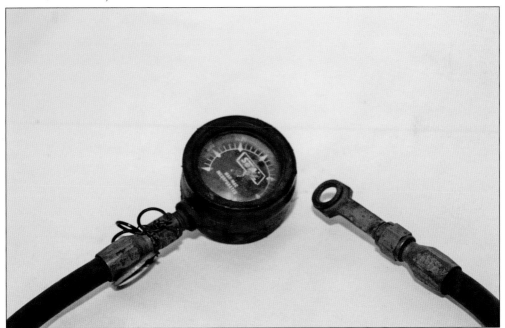

Knowing how much pressure (breathing air) is in one's tank is most desirable. At first, divers did not have this information, and it was a guessing game. There were no high-pressure ports on the first regulators to connect a high-pressure gauge, so this hose adapter was developed to fit between the regulator seat and the valve. (Courtesy of Paul Schorzman.)

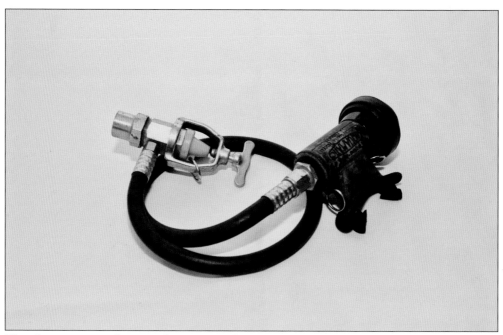

This Aquamatic regulator, made in France for US Divers in 1957 to 1961, was the first single-hose regulator on the market. Tom Hemphill's first regulator in 1959 was an Aquamatic. Jacques Cousteau developed this design with the side exhaust, as it would work with the hose coming over the right or the left shoulder, like European divers. (Courtesy of Paul Schorzman.)

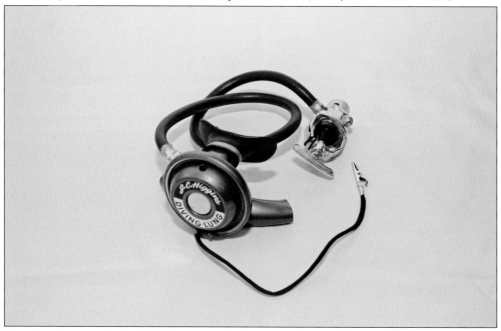

This is a photograph of a J.C. Higgins single hose regulator, sold primarily at Sears, Roebuck and Co. You can imagine how many people bought this equipment and went diving with zero training. J.C. Higgins also had a line of double hose regulators and other gear as well. (Courtesy of Paul Schorzman.)

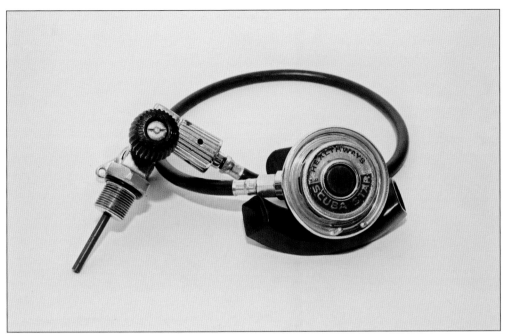

Here is a classic early-1960s vintage Healthways Scuba Star regulator, with a tilt valve second stage that got harder to inhale with depth and a screw-in first stage without the common yoke attachment. This was the first piston-type regulator—still no high-pressure port to connect a pressure gauge. (Courtesy of Paul Schorzman.)

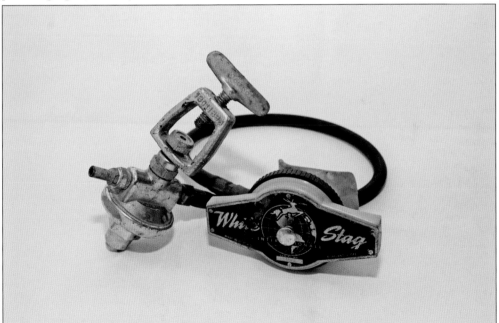

This photograph shows the first White Stag regulator in late 1950s. The first stage is a diaphragm design, and the second stage introduced a whole new design, which did not improve performance—it just looked cool. This regulator is well used, and it is not certain what the short tube is for, unless it was installed to connect a hose to a compressor. (Courtesy of Paul Schorzman.)

This is an interesting advertisement for a weight belt made by Tommy Amerman. Evidently, freight was cheap then. Note the instructions to use a nickel or quarter for a screwdriver. This was a new innovation to achieve a quick-release weight belt. Perhaps the buckles were military surplus, and Amerman got a deal on them. (Courtesy of Sid Macken.)

Divers need to equalize pressure in the ears, and to do so, it usually requires pinching and blowing through the nose to force air into the ears. However, when using heavy gloves or mitts, it is hard to reach the nose, so this mask with wire nose pinchers became popular with cold-water divers in Oregon. (Courtesy of Tom Hemphill.)

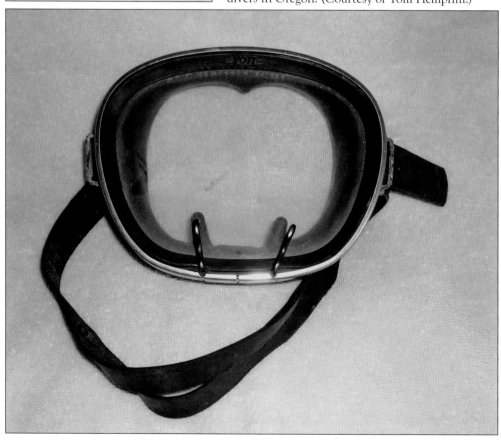

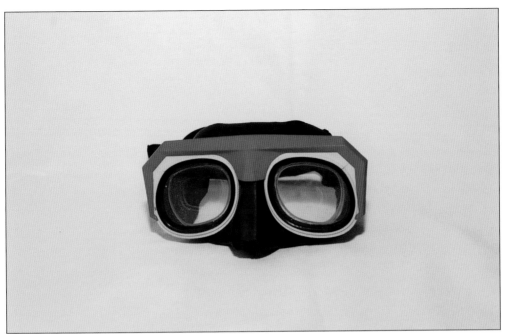

In the early 1970s, US Divers introduced this mask named the Falco, after one of Jacques Cousteau's favorite divers on his crew aboard the *Calypso* marine research vessel. The small-volume twin lens was a very popular design, and it was easy to pinch the nose with heavy diving gloves. (Courtesy of Tom Hemphill.)

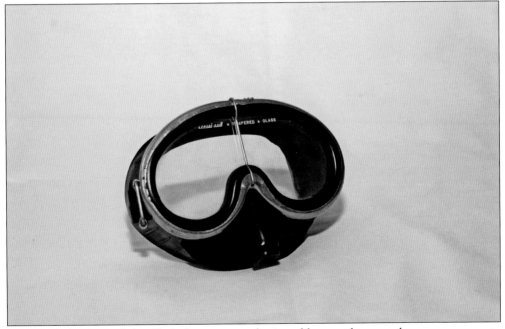

This mask, by Cressi Sub of Italy, became popular in cold waters because the nose was easy to access to equalize pressure in the ears. It was also a small volume and easy to clear out when it flooded. Some divers thought the center bar would annoy them, but the mask fit close to the face, and the bars were not an issue. (Courtesy of Tom Hemphill.)

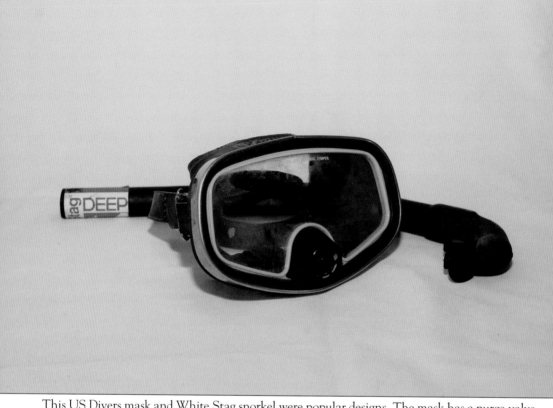

This US Divers mask and White Stag snorkel were popular designs. The mask has a purge valve (one-way valve) that makes clearing any water easier should the mask get flooded, and the snorkel is a close contour that fits close to the head. There are many examples where Oregon divers have influenced and contributed to the evolution of diving education and equipment. Most of the early development took place in California and Florida, where the water is warm. The addition of thicker suits with hoods and gloves changes how to train divers and adjust for the environment. In the Northwest, learning how to plan dives around the tides and currents is a must; divers do not do that in Florida and California. Northwest divers needed to develop techniques for "live boat" diving, because there is no place to anchor where they dive. With heavy wet suits and dry suits, they use more weight, so the buoyancy vests first developed were inadequate. Oregon divers told the industry to build buoyancy control systems that support more than twenty pounds, not six. (Courtesy of Tom Hemphill.)

Four

DIVE CLUBS AND THEIR ROLE IN PROMOTING DIVING

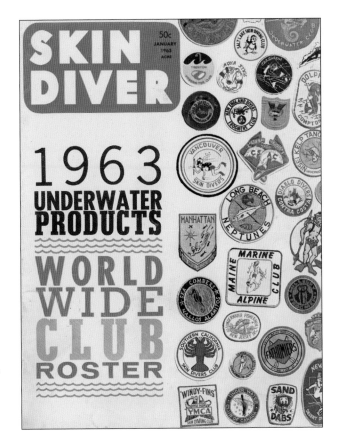

The January 1963 issue of *Skin Diver Magazine* features a "World-Wide Roster of Underwater Clubs." More than 1,100 dive clubs are on this roster, and nearly 90 are in the Northwest cold-water diving region. There are no clubs from Oregon listed officially; however, evidence and stories indicate that there were a few small clubs in Oregon at that time. (Courtesy of Tom Hemphill.)

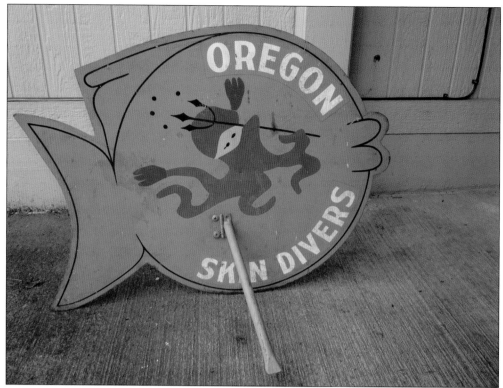

One of the first dive clubs that grew to be very popular was the Oregon Skin Divers. The primary focus of this club was sponsoring spearfishing competition, which was primarily skin diving (breath-hold) without the use of scuba. The more experienced divers in this club devoted their time and guidance to mentor new divers. Members were among the early diving pioneers who explored Oregon coast reefs for the first time. (Courtesy of Tom Hemphill.)

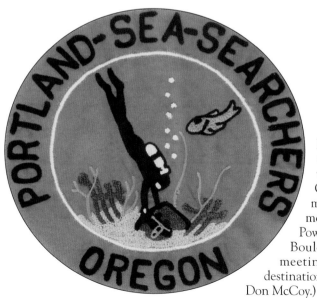

In 1963, the Portland Sea Searchers Club was formed, and it is still active today, more than 50 years later. Pete George was one of the founding members. In the late 1960s, the club met at Underwater Sports—first on Powell Boulevard, and then on Sandy Boulevard. The club holds monthly meetings and organizes dive trips to destinations around the world. (Courtesy of Don McCoy.)

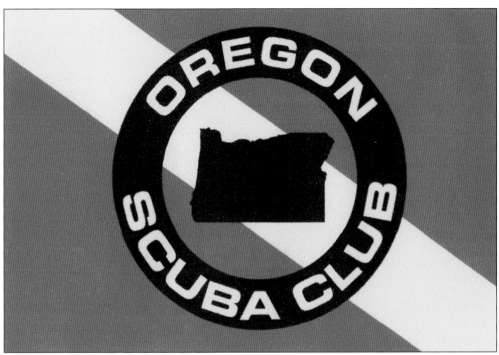

The Oregon Scuba Club is an independent club that is not associated with any dive retailer, and it supports all dive retailers. It holds monthly meetings with guest speakers and fun events and organizes monthly dives, where new divers can find an experienced buddy to dive with. (Courtesy of Jeff Groth.)

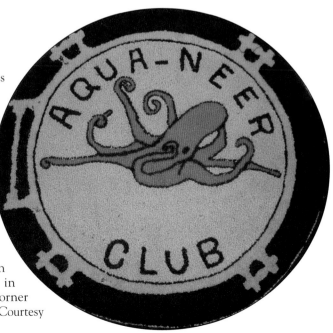

The Aqua-Neer Club was headquartered in Camas, Washington, and was very active for nearly 30 years, from the early 1950s until 1979. Ed Palamounter, a decorated World War II Navy UDT (Underwater Demolition Teams) frogman, was the club organizer, motivator, instructor, and master mentor. Palamounter began teaching diving before there were established certification agencies, and he participated in the early-1950s Instructor's Corner column in *Skin Diver Magazine*. (Courtesy of Tom Hemphill.)

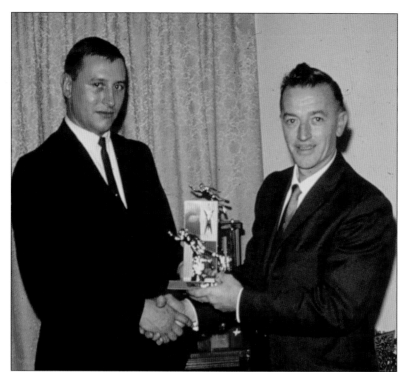

Pictured here are Tom Hemphill (left) and Ed Palamounter at the 1968 annual dinner and awards ceremony of the Aqua-Neer Club. Palamounter is presenting Hemphill with a trophy for the largest fish speared on a club dive that year. Many of the dives sponsored by the club were on the Oregon coast, several times each year. (Courtesy of Tom Hemphill.)

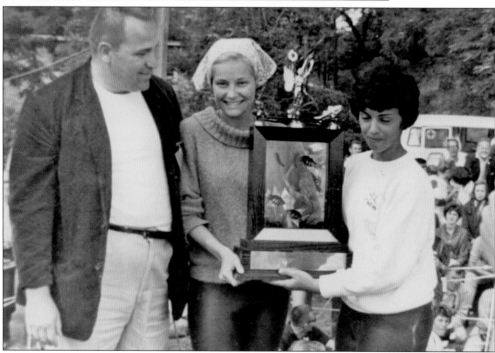

Oregon's women's spearfishing team of Bev Farrish and Marion Azor placed first in the women's division at the National Spearfishing Championships, held at Alki Point in Seattle, in 1963. These young women honed their free diving and spearfishing skills diving off the Oregon coast. They were members of the Oregon Skin Divers Club. (Courtesy of Bill High.)

This is an emblem for the Oregon Search and Rescue Associates, an organization that could be considered a club because it organizes recreational dives and conducts specialty training exercises. The Clackamas County Dive Rescue Team in Oregon was a volunteer group of sport divers and was listed as a dive club in 1963. (Courtesy of Paul Schorzman.)

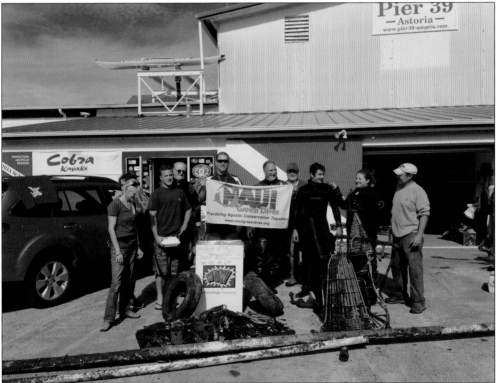

Here are divers from the Astoria Scuba Club doing their duty to clean up the environment as a project for the NAUI Green Diver program. The one common attitude among divers throughout the world is an appreciation for the environment and a desire to practice aquatic preservation. (Courtesy of Floyd Holcom.)

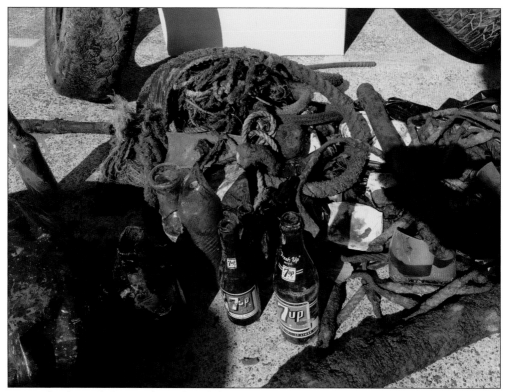

Pictured is the junk Astoria divers found cluttered underwater. Sometimes, treasure is to be found. About 150 years ago, it was common to dump trash in the water. Some of that trash consists of bottles and pottery that is worth a lot of money now. Divers also found old copper nails from rotted wooden boats. (Courtesy of Floyd Holcom.)

The Eugene Dive Club has been around since around 1980. Today, it has about 110 members. The club holds monthly meetings, organizes dive trips, and mentors new divers. Mentoring and dive-trip organizing are the most valuable missions for dive clubs. New divers, although trained and certified, still have a lot to learn, and they welcome the guidance. (Courtesy of Jim Pendergrass.)

Five

RETAIL DIVE STORES

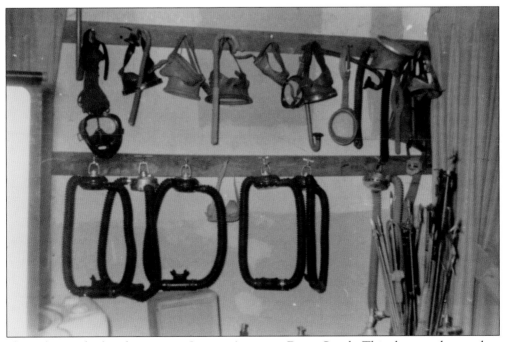

Shown here is the first dive store in Oregon, Amerman Divers Supply. This photograph was taken in either Tommy Amerman's living room or his garage in about 1953. Amerman rented equipment, though by the looks of this photograph, there was not much to rent. At this time, there was not much equipment available to go diving—just the bare necessities. (Courtesy of Sid Macken.)

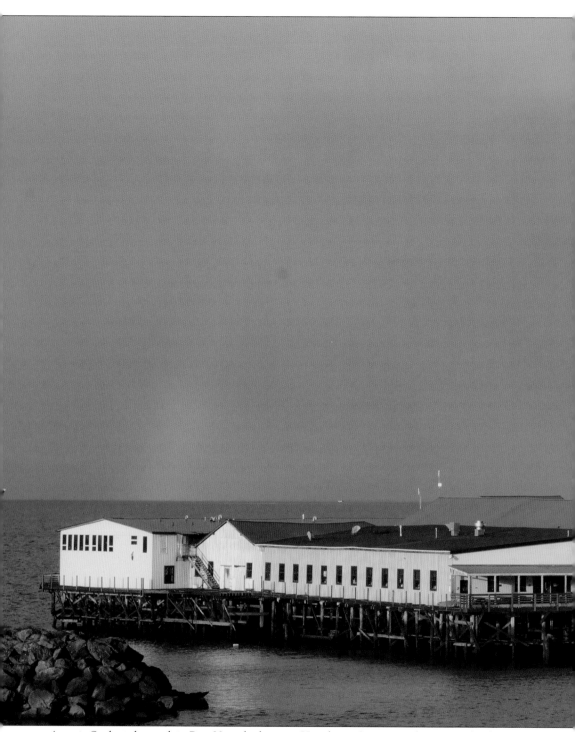

Astoria Scuba is located on Pier 39 at the historic Hanthorn Cannery. There are other businesses on the pier, including the Rogue Public House restaurant, the Coffee Girl, and the Hanthorn Cannery Museum. Upstairs, there are offices, luxury suites, and meeting rooms. Visitors and locals may enjoy the annual crab and seafood festival at the Rogue Brewery. Pier 39 and Astoria Scuba

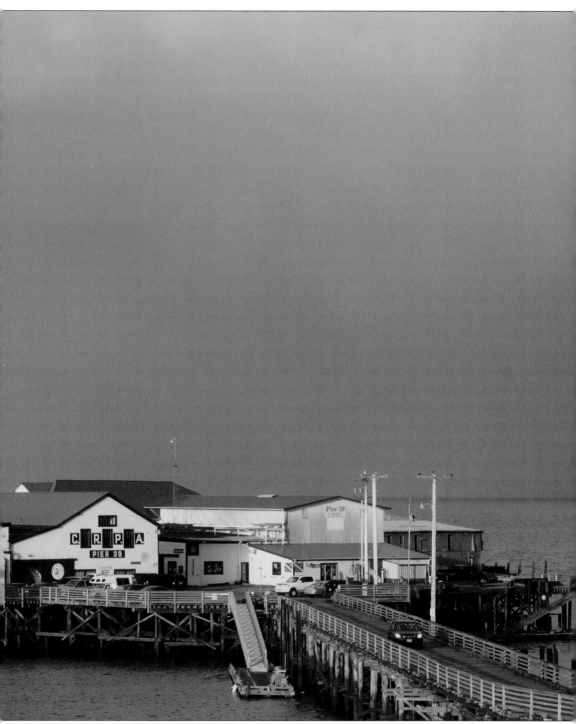

are both owned and managed by Floyd Holcom and his family. Astoria Scuba is the only year-round, full service diving retail store and service center on the Oregon coast. Its NAUI-certified diving educational programs include entry-level scuba, tech diving, leadership, and professional instructor training and certification. (Courtesy of Sid Macken.)

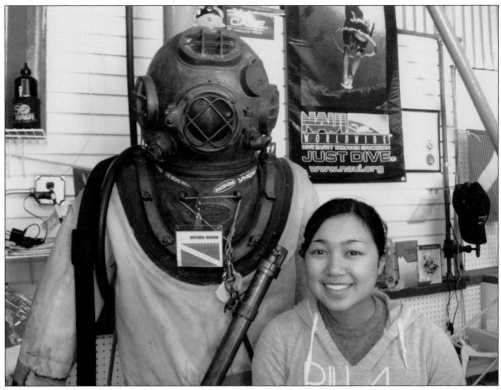

Astoria Scuba has a mini-museum displaying vintage diving equipment and there is always a friendly smile awaiting. Pictured here is Victoria Holcom, Floyd's daughter, standing by one of the historical displays. The dive store and the entire Pier 39 operation is a family affair. Visitors can rent a kayak here and paddle around the Astoria waterfront. (Courtesy of Floyd Holcom.)

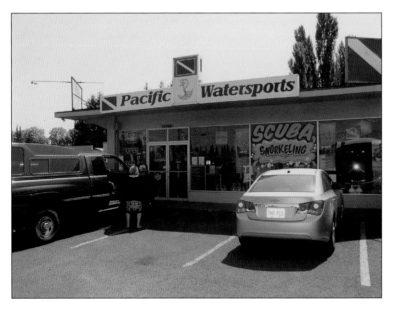

Inland from the coast, just a couple of miles off of Highway 26 and west of Portland, is Pacific Watersports, established in 1982. Laurie Hannula purchased the store in 1991, and it is the closest full-service, year-round diving retail, rental, training, and service center to the north Oregon coast. (Courtesy of Tom Hemphill.)

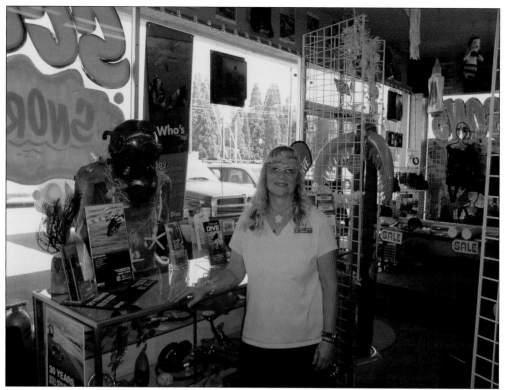

Pictured inside of Pacific Watersports is owner Laurie Hannula. Hannula learned to dive in 1977 when she took lessons from Tom Hemphill at Clark College in Vancouver, Washington. She was certified as a NAUI instructor in 1981 and as a PADI (Professional Association of Diving Instructors) instructor in 1988. Hannula, a diving history enthusiast, has a mini-museum of vintage diving equipment in her store. (Courtesy of Tom Hemphill.)

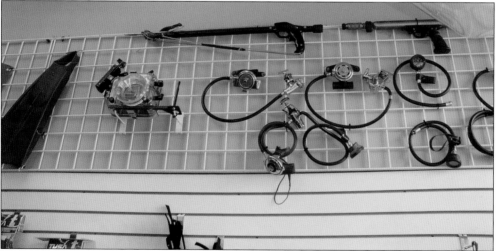

Looking around throughout Pacific Watersports, one will see vintage double-hose and single-hose diving regulators, spearguns, underwater camera housings, masks, fins, and other items of interest. Hannula has been collecting vintage diving equipment since the late 1970s, and many people that have retired from diving have contributed to her collection. (Courtesy of Tom Hemphill.)

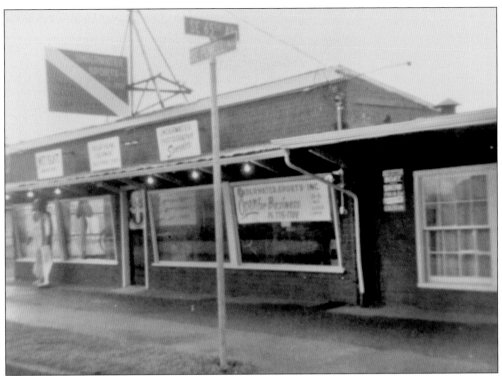

Jerry Hiersche established Underwater Sports at Southeast Sixty-Fifth Avenue and Powell Boulevard in Portland around 1962. Hiersche was quite charismatic and had a lot of enthusiastic followers. At this time, the training was becoming more formal, so Hiersche attended a NAUI instructor certification program in California and began offering the first nationally certified scuba training in Oregon. In 1968, he sold the store to Bill Dornes. (Courtesy of Sid Macken.)

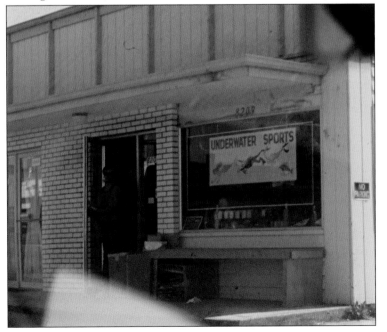

In 1974, Tom Hemphill purchased the compressor, rental gear, service tools, and supplies from Bill Dornes and relocated Underwater Sports to Vancouver, Washington. Hemphill was certified as a NAUI instructor in 1971 and had many students in Vancouver. He established Underwater Sports and began teaching at Clark College and other locations in the area. (Courtesy of Tom Hemphill.)

Pictured is the Mount St. Helens eruption, as seen from the front parking lot of Underwater Sports in May 1980. This was the fourth location for the store, just down the street from the first Vancouver location. Tom Hemphill had purchased an old house and converted it into a retail store on the main floor and classroom on second floor. (Courtesy of Tom Hemphill.)

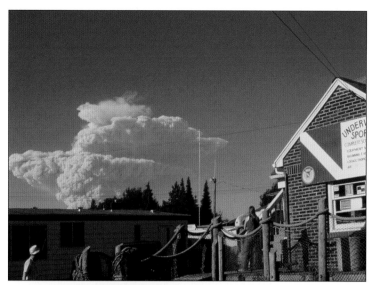

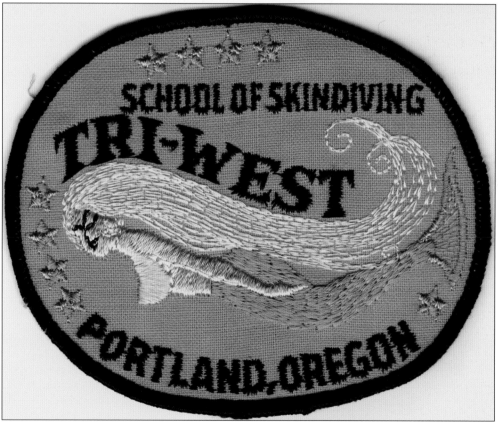

In 1970, Paul Schorzman and some partners established the Diving Bell retail store and service center at Southeast 136th Avenue and Powell Boulevard in Portland. The educational arm of the business was named Tri-West School of Skindiving, as the emblem in the photograph illustrates. Schorzman focused mostly on education, while his partners ran the retail store. (Courtesy of Paul Schorzman.)

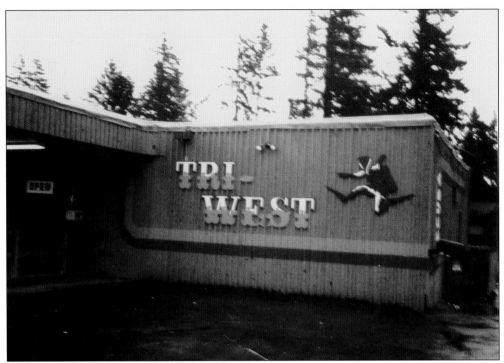

Here is a photograph of Tri-West Scuba in the early years. A few years after the store was established, Paul Schorzman took over full ownership of the business and dropped the name Diving Bell. His passion was teaching, but he was also a great retail salesman and businessman. (Courtesy of Paul Schorzman.)

This is another view of Tri-West Scuba a few years later with a new paint job. The location was ideal, on a busy road and easy to find. In 1977, Tom Hemphill called Paul Schorzman, and they coordinated the use of Sunrise Resort on Hood Canal used for open-water scuba training. Between them, they booked the resort for every weekend for a year in advance. (Courtesy of Paul Schorzman.)

In 1993, Ron Tinker, one of the instructors who had worked with Paul Schorzman, established his own business and leased the store from Schorzman. Tinker renamed the store Adventure Sports, and Schorzman became one of the instructors—a role reversal. The two guys remain friends, and Schorzman is still teaching classes for Tinker. (Courtesy of Paul Schorzman.)

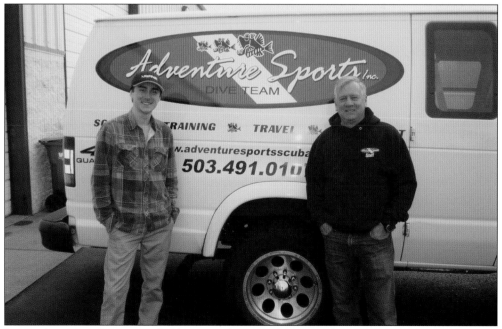

Pictured are Eric Stevenson (left), an employee, and Ron Tinker, owner of Adventure Sports Scuba. Ron moved his store in 2013 to a facility in Wood Village, Oregon. Ron runs a lot of dive trips to many parts of the world, including the Oregon coast. However, he did admit that his favorite dive is at the Wakatobi Resort in Indonesia. (Courtesy of Tom Hemphill.)

This image was captured during a Eugene Skin Divers Supply special event. Michael and Diana Hollinghead own and operate this store, and they have a lot of fun with their customers. The store was established in 1956 by Don Hollingshead, and was first operated out of the backroom of an appliance store. In 1969, Hollingshead moved the store to its current location on Sixth Street. (Courtesy of Michael and Diane Hollingshead.)

In 1992, the building was completely remodeled and expanded. Eugene Skin Divers Supply is the closest year-round, full service dive center for divers heading to the central and south Oregon coast. Because it work closely with the Oregon Coast Aquarium divers, its is a great resource for divers to find out about dive sites. (Courtesy of Michael and Diane Hollingshead.)

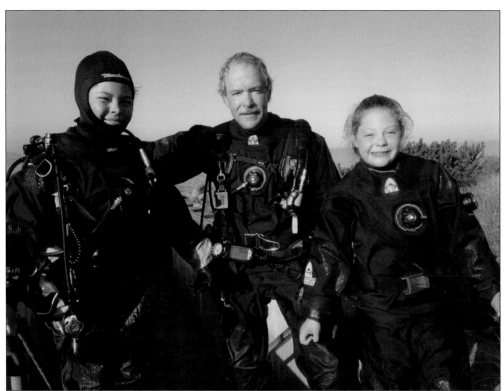

Michael (center) and two young divers get ready for a dive on the Oregon coast with their USIA dry suits, a popular brand of diving dry suits made in Oregon. Diana Hollingshead, Michael's wife and partner, is very involved with the Oregon Coast Aquarium, sponsoring tours and taking people diving in the aquarium and working with kid's programs. (Courtesy of Michael and Diane Hollingshead.)

This is an early-1970s photograph of Don Hollingshead, founder of Eugene Skindivers Supply. The photograph was taken by Ron Church, a world-renowned underwater photographer and author. Church was working for a camera company at that time, and Hollingshead was selling underwater photography equipment. Church was also one of the photography team members on Jacques Cousteau's team. (Courtesy of Michael and Diane Hollingshead.)

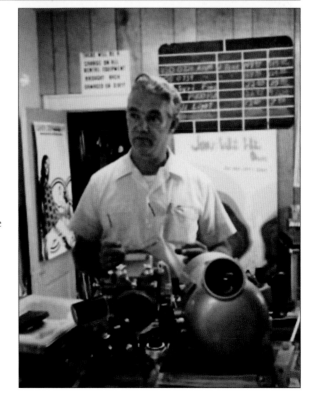

HYDROSPORTS
Dive and Travel

HydroSports Dive and Travel, located in Keizer, Oregon, just north of Salem, is a good resource and supply depot when heading for the central Oregon coast for diving. Owner Mark Fischer is a very experienced PADI instructor, and he is always willing to assist divers with planning Oregon coast diving excursions. He may even talk visitors into a tropical dive vacation with the HydroSports crew. (Courtesy of Mark Fischer.)

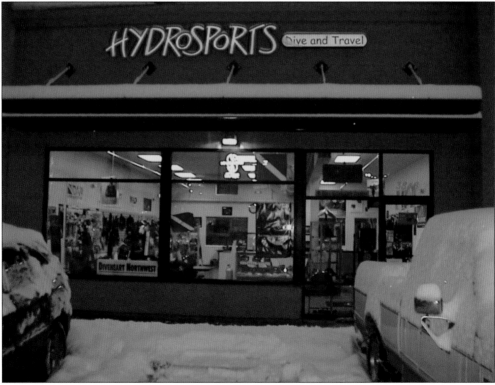

HydroSports Dive and Travel is a full-service diving facility offering PADI-certified lessons, equipment rentals and service, new equipment counseling, and, of course, dive travel. Mark Fischer has built his successful business around a friendly attitude, with all of the members of his professional team making the customers always feel welcome. (Courtesy of Mark Fischer.)

Six

POPULAR DIVE SITES ALONG THE OREGON COAST

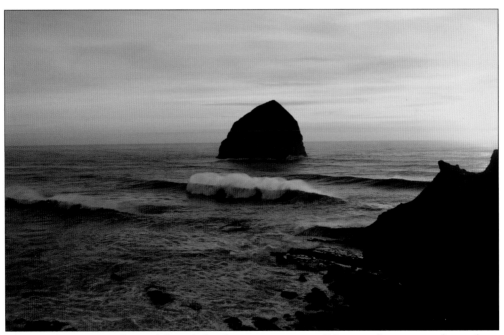

The Pacific Ocean is beautiful, and the Oregon coast is well known for its rugged coastline, beaches, offshore rocks, and reefs. This photograph shows Haystack Rock at Pacific City, a very popular dive site. Getting to the rock requires a kayak, paddleboard, or small boat launched from the beach. (Courtesy of Karl Anderson.)

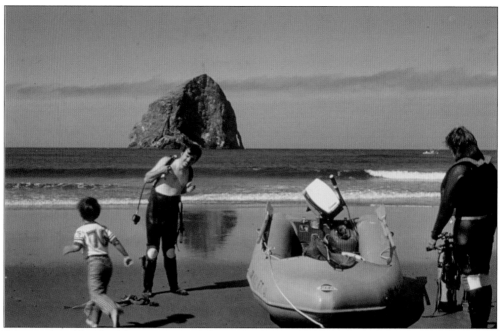

Don McCoy (shirtless) has just returned from an exciting dive around Haystack Rock. He and his buddy launched his inflatable boat into the surf and rode it back to shore. McCoy began diving in 1971 and is one of the leaders in the Portland Sea Searchers dive club. (Courtesy of Don McCoy.)

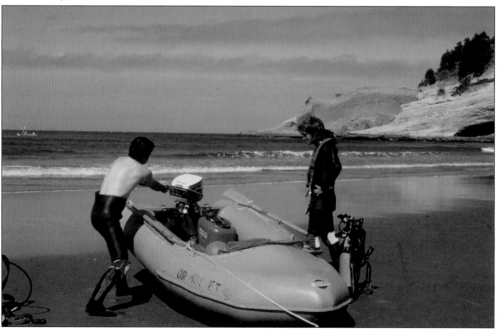

This other view of the beach and the cliffs north of Haystack Rock shows some other good dive sites from the Pacific City beach. Out past the rock, there are several reefs where the diving is great. There is a Pacific City dory that is made by a few boatbuilders and is designed to be launched on the beach when the waves recede. (Courtesy of Don McCoy.)

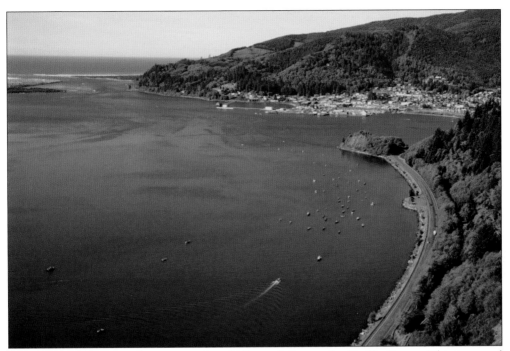

This photograph shows the opening from Tillamook Bay to the Pacific Ocean. This is a good area for Dungeness crab, and the rocks out on the jetty offer good diving and, usually, lots of fish. This is a popular area because there is access from the shore at many locations. Divers take boats out of Garibaldi and get to reefs outside of the bay. (Courtesy of Karl Anderson.)

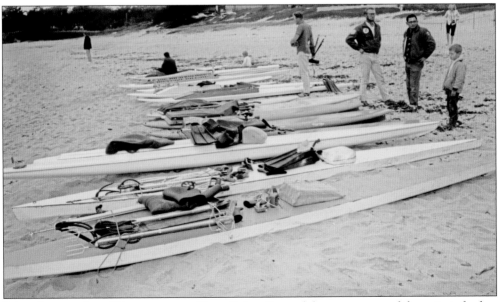

It is a chore getting offshore to some of best diving. Some clubs sponsor spearfish contests for free diving only, and the divers use paddleboards to get to the reefs and rocks. This photograph shows a bunch of paddleboards lined up and ready to start the competition. (Courtesy of Bill High.)

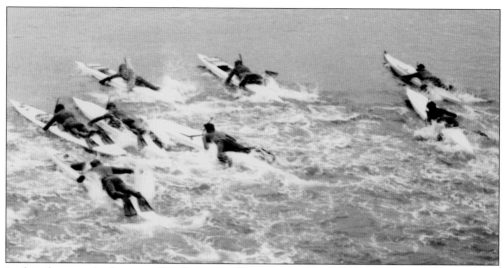

In this photograph, they are off and running. The contest has started, and the divers are heading out to their favorite hunting grounds. Paddling one of these boards is a combination of using one's hands as paddles and fins with a crazy frog kick for propulsion. The spearguns and stringers are inside of the fish well when under way. (Courtesy of Bill High.)

This diver is getting ready for a beach dive at Gold Beach with a float and dive flag. Anytime divers are in an area where boats may be coming by, its necessary to have a dive flag displayed to warn boaters to be on the lookout for a diver or bubbles on the surface. (Courtesy of Rod Shroufe and Dan Semrad.)

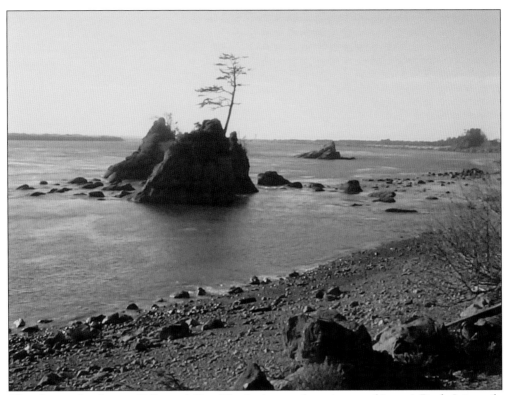

This cluster of rocks is in Tillamook Bay. The farthest rock out is named Lyster's Rock. It is easily accessed by parking in a small grassy lot adjacent to the jetty and closest to the rock, gearing up, crossing the railroad tracks, and climbing over the jetty rocks to the water. The outer (southern) side of the rock is 60-feet-maximum depth. (Courtesy of Karl Anderson.)

This picture shows the dive boat *Fast Enuff,* owned by Ron Tinker of Adventure Sports Scuba in Portland. The two divers are in Garibaldi Harbor and getting ready to go do some offshore spearfishing. This is a common type and size of boat used for diving the Oregon coast on a good day. (Courtesy of Ron Tinker.)

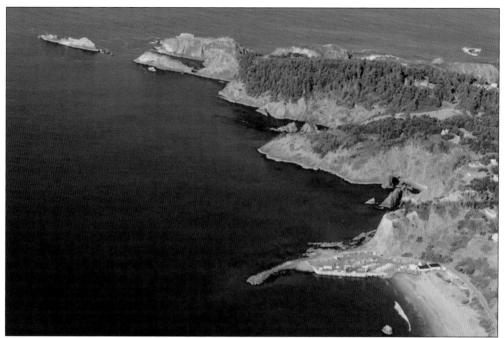

From this point of view, the Port Orford marina and the coastline just north of the jetty can be seen. Divers can access several dive sites from the beach along the jetty. There is a boat lift to launch boats and no jetty to cross. There are dozens of sites for diving by boat in this area. (Courtesy of Karl Anderson.)

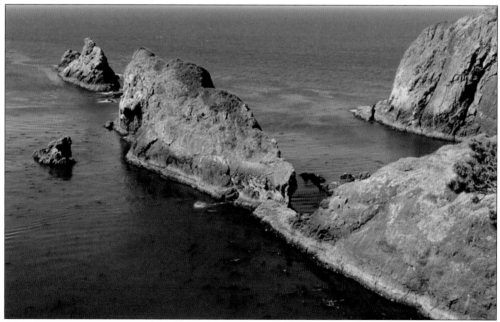

This is a closer look at the point just north and west of the Port Orford marina. As seen here, the kelp forests and rocky coastline offers some great diving opportunities, and it is close to the harbor. It is also protected from the northwest winds and currents that are typical along most of the coast. Using a small inflatable works well to dive these sites. (Courtesy of Karl Anderson.)

In this view looking out from Port Orford are several rock pinnacles sticking up out in the ocean. These rocks and reefs offer extraordinary diving. Some of the outside reefs drop straight down, well over 100 feet, and there is an abundance of rockfish, lingcod, and huge rock scallops. (Courtesy of Jim Burke.)

This is a nautical chart showing Tillamook Head, a rocky point between Seaside and Cannon Beach. Access to this site is by boat. Launching a boat from the Hammond Mooring Basin, it is a 45-minute boat ride takes to "Terrible Tilley," where advance and master divers see huge sea scallops, beautiful sea anemones, abundant sea life, and a famous but difficult wreck nearby. (Courtesy of Tom Hemphill.)

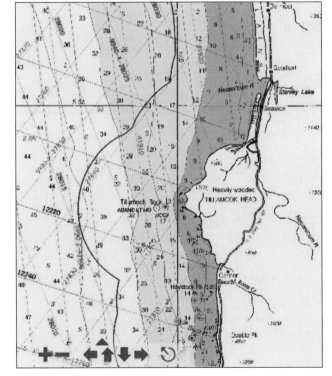

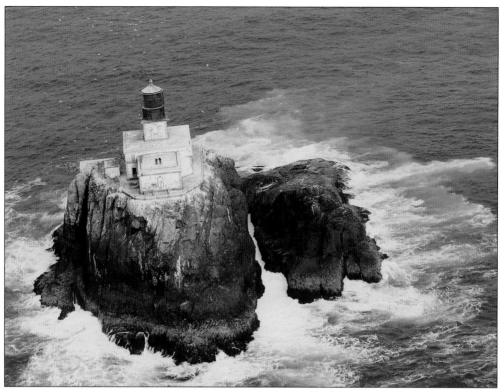

Just off of Tillamook Head is an old abandoned lighthouse. The best diving here is on the outside of the rock, in the kelp or off the underwater cliff that drops down well over 150 feet. The canyons and small caves at this site are home to many colorful rockfish, octopuses, and lingcod. (Courtesy of Floyd Holcom.)

This is Rod Shroufe, co-owner of Scuba Specialties NW in Oregon City, getting ready to enter the water at Barview Jetty. Spearfishing is fair in this area, but the crabbing is great. On a calm day, the entry and exit is easy; however, on a day when the waves are larger, it becomes more challenging to get in and out over the rocks. (Courtesy of Rod Shroufe and Dan Semrad.)

This photograph shows Tom Henderson with a few fish on his stringer that is attached to his belt. Using no scuba tank, he free dives and silently cruises over a reef, hunting for the right species of fish and the right size. Henderson has been an avid diver since the 1960s. (Courtesy of Josh Humbert.)

After making a breath-holding dive, Tom Henderson is ascending. The visibility off of the Oregon coast is excellent by Northwest diving standards, especially in the late summer and early fall. The Japan Current brings tropical blue water up from the South Pacific and across the ocean to the Oregon coast, where it then turns south, resulting in warm, blue water on the shores. (Courtesy of Josh Humbert.)

Rod Shroufe is exiting on rocks at the Barview jetty on a pretty calm day, but when the waves are larger, getting out of the water onto the rocks is a timing challenge. Divers watch and count the waves, and when a big one heads their way, they ride it to the highest point they can reach, then climb out and up as fast as possible. (Courtesy of Rod Shroufe and Dan Semrad.)

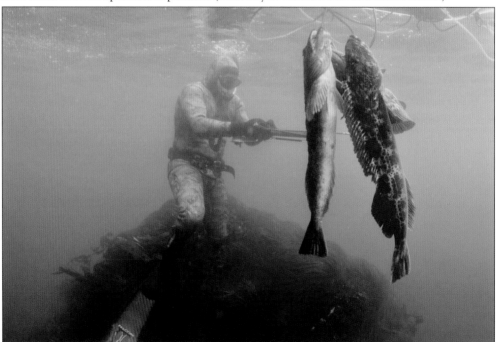

Here is another successful day of hunting lingcod. Tom Henderson, a master free diver, knows where and how to hunt the best area of the Oregon coast. He is an avid ocean conservationist because he sincerely appreciates the quality of the oceans. (Courtesy of Josh Humbert.)

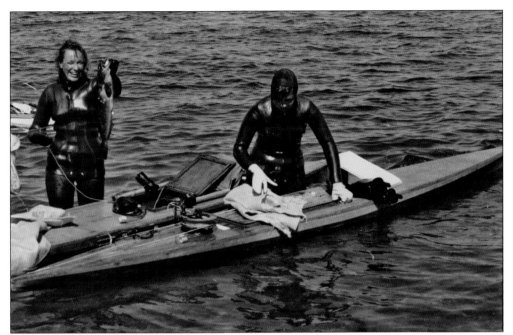

This is a photograph of two women divers with paddleboards after a successful spearfishing dive. In the 1960s and 1970s, paddleboards were very popular because they could launch from any beach and get out to the offshore reefs and rock formations. As this photograph illustrates, diving is a woman's sport as much as a man's. (Courtesy of Bill High.)

The paddleboards, usually custom made, had fairly large storage areas (called fish wells—but anything that fit could go in there), and most of them had a latching lid. This photograph shows a free diver putting a large lingcod into the fish well after a successful dive. (Courtesy of Bill High.)

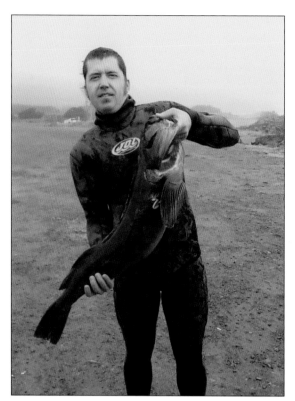

This photograph is of Dan Semrad II with 40-inch lingcod that he was able to spear. Lingcod, for most people, is the best-tasting fish of the Oregon coast. The average size is 20 to 30 pounds; however, there have been big lings caught that weighed more than 100 pounds. (Courtesy of Rod Shroufe and Dan Semrad.)

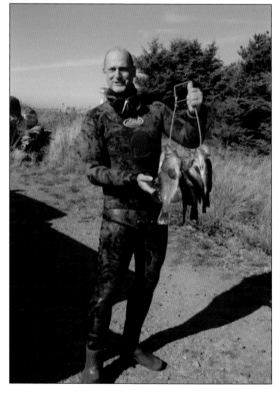

This is Rod Shroufe with a stringer full of nice size rockfish for dinner. Rockfish are smaller than lingcod, but very plentiful off of the Oregon coast—and quite tasty as well. It appears that the boys had a great day, and the family will be well fed for a while. (Courtesy of Rod Shroufe and Dan Semrad.)

Off the southern Oregon coast, between Brookings and Gold Beach, there are lots of reefs where divers can harvest abalone. As of this writing, the daily limit for abalone is one per person, per day. There is no way to fish for abalone other than to dive. They are not too deep, so free divers are able to find them in many areas. (Courtesy of Rod Shroufe and Dan Semrad.)

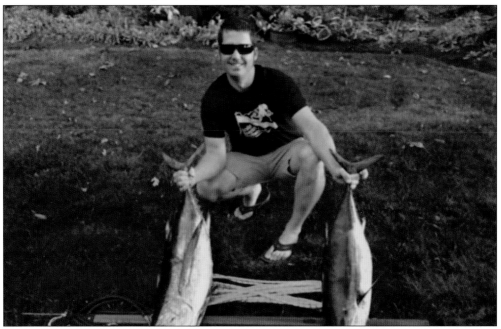

Here is the result of training and being is great shape for free diving. Dan Shroufe II went 30 miles offshore into the blue water and went hunting for albacore tuna. This is the ultimate challenge for a diver. Blue water diving refers to deep open-ocean diving, where there is no bottom that the diver can see. (Courtesy of Rod Shroufe and Dan Semrad.)

The Northwest Diving History Association is a registered 501(c)(3) nonprofit membership organization devoted to recording, preserving, and sharing the history of diving in the Northwest. The association offers special entertaining and educational presentations for clubs and other groups to share this history with the general public. The image on this page shows the association logo. (Courtesy of Paul Hoge.)